THE POETRY OF TRANSLATION

KUNST MERAN MERANO ARTE
MOUSSE PUBLISHING

VORWORT

MARTINA OBERPRANTACHER

Für Südtirol ist Übersetzung etwas, das sich nicht nur in einem linguistischen Zusammenhang verorten lässt. Es ist vielmehr etwas, das zu allen Bereichen des Lebens – tagtäglich – dazugehört.

Als Kind dachte ich mir, dass die italienischsprachigen Nachbarskinder eigentlich auch im Südtiroler Dialekt denken müssten, aber sich – eigenartigerweise – nur über die italienische Sprache artikulieren konnten. Dass, um sie zu verstehen, ich diejenige war, die den Übersetzungsprozess durchlief und nicht sie, war mir damals als Kind nicht klar. Der Sohn eines befreundeten deutschsprachigen Paares widmete sich ebenfalls als Kind dem Verstehen und Nicht-Verstehen einer anderen Sprache. Seine Sorge galt der Erstsprache seines Geschwisterkindes, denn: „was tun, wenn das frischgebackene Baby anstatt Deutsch nur Italienisch spricht?".

Ständig prägt die Übersetzung unseren Alltag. Ob wir uns von online-basierten Programmen Texte übersetzen lassen oder ob Sprachmittler*innen in Asylverfahren und auf Behördengängen die Verständigung zwischen unterschiedlichen Sprachen ermöglichen – immer wieder beschäftigen wir uns (häufig auch ganz unbewusst) mit Übersetzung. Da dem Übersetzen etwas Alltägliches, ja schon fast Gewöhnliches anhaftet, gerät oft das Feinsinnige und Ästhetische des Übersetzungsprozesses aus dem Blick. Ebenso die Bedeutung, die mit dem Willen einhergeht, mit anderen Menschen kommunizieren und von ihnen verstanden werden zu wollen. Dass oft Missverständnisse entstehen, liegt weit weniger an der Übersetzung selbst als vielmehr an der Problematik der Verschiedenheit zwischen dem Senden und dem Empfangen.

Daher danke ich Judith Waldmann, Kuratorin der Ausstellung und Herausgeberin der hier vorliegenden Publikation, sehr für die Sensibilität, die sie diesem Thema entgegenbringt. Sie hat es verstanden, das Phänomen Übersetzung durch die gewählten künstlerischen und literarischen Positionen vielgestaltig zu präsentieren und es durch Referenzen aus dem kulturwissenschaftlichen Kontext zu flankieren. Ebenso war es ihr wichtig, durch die Wahl rassismuskritischer und feministischer Standpunkte populistisch motivierten Auslegungen von Sprachtransfer etwas entgegenzusetzen. Von akuter Relevanz ist die Fragestellung dieser Publikation und der Ausstellung auch deshalb, da die von ihr angestoßene Diskussion aufzeigt, dass sich das Übersetzen widerspruchsfreien Raum abspielt, sondern sich zwischen Versöhnlichem und Polarisierendem bewegt.

Mein Dank geht auch der kuratorischen Assistentin Anna Zinelli sowie allen weiteren Mitarbeiter*innen von Kunst Meran, so Ursula Schnitzer, Shpresa Perlaska und Kathrin Blum sowie Federica Bertagnolli, Hannes Egger und Barbara Wielander für die Arbeit vor und hinter der Ausstellungsbühne. Dem Vorstand des Kunstvereins Kunst Meran, allen voran dem Präsidenten Georg Klotzner, sei für die fortwährende Unterstützung gedankt.

Ein besonderer Dank geht an das Institut für Auslandsbeziehungen (ifa) e.V. in Stuttgart sowie an Alperia, an die Stiftung Südtiroler Sparkasse und an die Kulturabteilungen der Autonomen Provinz Bozen – Südtirol, der Stadtgemeinde Meran und der Autonomen Region Trentino – Südtirol. Ohne ihren wertvollen Beitrag wäre weder die Realisierung der Ausstellung noch die der Publikation in dieser Form möglich gewesen.

Martina Oberprantacher, Direktorin
Kunst Meran Merano Arte

PREMESSA

MARTINA OBERPRANTACHER

Per l'Alto Adige la traduzione è qualcosa che non si limita ad essere collocata in un contesto linguistico ma che riguarda, piuttosto, tutti gli ambiti della vita quotidiana. Quando ero bambina, pensavo che anche i bambini del vicinato di lingua italiana dovessero pensare in dialetto altoatesino ma che, stranamente, potessero poi articolare questi pensieri soltanto in lingua italiana. All'epoca, mi era poco chiaro il fatto che fossi io, e non loro, ad attraversare un processo di traduzione per capirli. Anche il figlio di una coppia di miei amici di madrelingua tedesca, quando era piccolo, si è confrontato con la questione del capire o non capire un'altra lingua. In particolare la sua preoccupazione, in occasione dell'arrivo di un nuovo fratellino o di una nuova sorellina, riguardava la prima lingua che avrebbe parlato: "come farò, dopo la nascita, se parlerà solo italiano e non tedesco?".

La traduzione influenza costantemente le nostre giornate. Ci confrontiamo con essa (spesso inconsciamente) ogni volta che utilizziamo servizi di traduzione di testi online, ma è anche lo strumento che consente ai mediatori e alle mediatrici interculturali di comunicare tra diverse lingue quando si occupano delle richieste di asilo o dei rapporti con le autorità. L'aspetto quotidiano, quasi ordinario, inerente alla traduzione determina il fatto che, spesso, si perdano di vista gli aspetti più sensibili ed estetici inerenti a questo processo così come il significato legato alla volontà di comunicare con altre persone e farsi capire da loro. Il fatto che spesso sorgano delle incomprensioni in diversi casi è dovuto, più che alla traduzione in sè, al problema delle differenze tra destinatario e mittente. Sono quindi molto grata a Judith Waldmann, curatrice della mostra e di questa pubblicazione,

per la sensibilità attraverso cui ha affrontato questa tematica. È riuscita infatti a restituire la complessità di questo fenomeno attraverso una selezione di ricerche artistiche e teoriche, ma anche a integrarlo in relazione al contesto dei cultural studies. Al contempo, rifacendosi a posizioni antirazziste e femministe, ha sottolineato l'importanza di contrastare interpretazioni di matrice populista dei passaggi linguistici. La questione posta da questa pubblicazione e dalla mostra è anche di forte attualità inquanto apre un dibattito su come la traduzione non avvenga in uno spazio scevro da contraddizioni ma oscilli piuttosto tra la conciliazione e la polarizzazione.

Vorrei ringraziare anche l'assistente curatoriale Anna Zinelli e tutto lo staff di Kunst Meran Merano Arte, quindi Ursula Schnitzer, Shpresa Perlaska e Kathrin Blum, e inoltre Federica Bertagnolli, Hannes Egger e Barbara Wielander per tutto il lavoro svolto, davanti e dietro le quinte. Ringrazio poi, per il sostegno costante, il consiglio direttivo della nostra associazione artistica e in primo luogo il presidente Georg Klotzner. Rivolgo un particolare ringraziamento, infine, all'Institut für Auslandsbeziehungen (ifa) e.V. di Stoccarda, ad Alperia, alla Fondazione Cassa di Risparmio di Bolzano, alle Ripartizioni Cultura della Provincia Autonoma di Bolzano – Alto Adige, del Comune di Merano e della Regione Autonoma Trentino-Alto Adige/Südtirol. Senza il loro prezioso sostegno non sarebbero stato possibile realizzare in questa forma né la mostra né questa pubblicazione.

Martina Oberprantacher, Direttrice
Kunst Meran Merano Arte

FOREWORD

MARTINA OBERPRANTACHER

For South Tyrol, translation is something that is not only to be found in a linguistic context: it is rather something that is part of all areas of life – every single day.

As a child, I thought that the Italian-speaking children in the neighbourhood actually had to think in South Tyrolean dialect as well, but – strangely enough – could only express themselves in Italian. The fact that, in order to understand them, it was I who was going through the translation process, rather than them, was not clear to me as a child at the time. Similarly, the son of a German-speaking couple, friends of ours, devoted himself as a child to the understanding and non-understanding of another language. He was worried about his new sibling's first language, because "What will we do if the new baby can only speak Italian instead of German?".

Translation constantly shapes our everyday lives. Whether we use online programs to translate texts or we appoint mediators to facilitate communication between different languages during asylum procedures or contacts with the authorities, we are always (often unconsciously) concerned with translation. As translation appears something commonplace, almost ordinary, the subtlety and aesthetics of the translation process are often lost to sight: likewise the meaning that goes hand-in-hand with the will to communicate with other people and be understood by them. The fact that misunderstandings often arise is far less due to the translation itself than to the problematic differences between sending and receiving.

I am therefore very grateful to Judith Waldmann, the curator of the exhibition and editor of this publication, for her sensitivity in respect of this subject. She has understood how to present the phenomenon of translation in a multifaceted way via the chosen artistic and literary positions, accompanying it with references taken from the context of cultural studies. She also felt that it was important to help counter populist interpretations of language transfer by choosing positions that are critical of racism and positive as regards feminism. The question posed by this publication and the exhibition is also of acute relevance, as the discussion it has initiated shows that translation does not occur in a space free of contradictions, but instead moves between the conciliatory and the polarising.

I would also like to thank the curatorial assistant Anna Zinelli and all the other staff of Kunst Meran Merano Arte, notably Ursula Schnitzer, Shpresa Perlaska and Kathrin Blum, as well as Federica Bertagnolli, Hannes Egger and Barbara Wielander for their work both in front of and behind the scenes. My thanks too go to the board of the Kunst Meran artistic association and especially its president Georg Klotzner for the ongoing support provided.

Finally, special thanks go to the Institut für Auslandsbeziehungen (ifa) e.V. in Stuttgart, as well as to Alperia, to the Südtiroler Sparkasse Foundation and to the cultural departments of the Autonomous Province of Bozen/Bolzano – South Tyrol, the Municipality of Meran(o) and to the Autonomous Region of Trentino – South Tyrol, without whose valuable contributions neither the exhibition nor this publication would have been possible.

Martina Oberprantacher, Director
Kunst Meran Merano Arte

EINLEITUNG ÜBERSETZUNG — EIN MAGISCHER PROZESS BEI DEM ETWAS NEUES ENTSTEHT

JUDITH WALDMANN

„[...] what I consider to be one
of the most important arts of the future:
the art of translation."
Édouard Glissant (1928-2011)
Schriftsteller, Dichter und Philosoph

Kunst Meran Merano Arte geht mit „The Poetry
of Translation" dem spannungsreichen Phänomen
der Übersetzung auf die Spur. Über 30 nationa-
le und internationale Künstler*innen beleuchten
in über 70 Arbeiten den Prozess der Übersetzung
aus neuartigen Perspektiven.
Inspiriert von der gelebten Mehrsprachigkeit
in Südtirol und seiner bewegten Geschichte intereth-
nischen Zusammenlebens, bietet Kunst Meran
Merano Arte den idealen Kontext für eine Ausstel-
lung, die sich der Übersetzung widmet und Fra-
gestellungen zu Identität, Multikulturalismus
und Diversität aufruft.
Übersetzung wird in der Gruppenschau in ihrer
Komplexität behandelt: Zum einen als Quelle
von Teilhabe, internationaler Verständigung, Kre-
ativität, Genius und Poesie, zum anderen als
Ursache von Missverständnissen und Ausgrenzung.
Sie wird hierbei als kreativer Prozess verstanden,
bei dem auch immer etwas Neues entsteht.
Ausgehend von der Übersetzung von einer Sprache
in eine andere, öffnet sich die Ausstellung dem
Transfer von weiteren (künstlerischen) Zeichen-
systemen wie Musik, Gesang, Tanz, Farbe, Licht,
digitalen Codes oder Malerei.
Zu Beginn von „The Poetry of Translation" ver-
weist die Arbeit „Disputed Utterance" (2019)
des britisch-libanesischen Künstlers Lawrence Abu
Hamdan auf 7 juristische Fälle, bei welchen
Missverständnisse im Zentrum stehen. So kreisen
die jeweiligen Prozesse um Fragen wie: Hat
der spanische Bungee-Jump Lehrer: „NOW JUMP"
oder „NO JUMP" gerufen, bevor einer seiner
Kunden den tödlichen Sprung in die Tiefe antrat?
Videoarbeiten wie „Classified Digits" (2016)
von Christine Sun Kim und Thomas Mader oder
„Answer me" (2008) von Anri Sala, gehen weiter
und loten die Möglichkeiten zwischenmenschlicher
Kommunikation innerhalb verschiedener – nicht
ausschließlich verbal-sprachlicher – Zeichensyste-
me aus. Das in Salas Werk geführte Trennungs-
gespräch eines jungen Paares wird sowohl in Spra-
che als auch in Musik geführt. Auf die Fragen
der Frau antwortet der Mann nicht verbal, sondern
mit energischen Trommelwirbeln. Sun Kim,
die gehörlos geboren wurde, übersetzt zusammen
mit ihrem Partner hingegen alltägliche Situatio-
nen, wie beispielsweise: „One person attempting
to join a group conversation", mit Hilfe von
Gesichtsmimik und der Gestikulation der Hände.
Die Präsentation des Phänomens Übersetzung
wird um Werke erweitert, in welchen etwa Tanz
durch von 32 senkrecht herunterhängenden
Neonröhren in Lichtsignale überführt wird
(Heid und Griess, „Untitled", 2013) oder Musik
in Zeichnung (Jorinde Voigt, "Ludwig van
Beethoven / Sonate Nr. 1 bis 32", 2012). Es wird
abstrakter und der poetische Moment der Über-
setzung tritt in den Vordergrund.

Bei diesen künstlerischen Arbeiten sind wir mit
Codes konfrontiert, die sich – wie eine fremde
Sprache – nicht direkt entschlüsseln lassen. Es geht
um das Verstehen und das Nicht-Verstehen, um
Dekodieren, aber auch um Phantasie, Assoziation
und Interpretation – und schlussendlich um Teil-
habe, sowie um Barrieren und Ausgrenzung.
Wie reagieren wir, wenn wir uns mit einem Code
konfrontiert sehen, den wir nicht verstehen?
Diese in der Ausstellung erlebbare Erfahrung findet
Ihre Fortsetzung in der Ihnen vorliegenden Begleit-
publikation. Einzig die einführenden Worte wurden
ins Englische, Italienische und Deutsche übersetzt.
Die Werktexte, sowie die Auswahl an theoretischen
Ausführungen zum Thema, sind ohne Überset-
zung in der Erstsprache der Autor*innen oder der
Originalsprache des jeweiligen Textes abgedruckt.
Hierbei ist es wichtig anzumerken, dass die weni-
gen, ausschließlich europäischen Sprachen, die
in der Publikation vorkommen, einzig ein Bruch-
teil der weltweit über 7000 Sprachen wiedergeben
– und auch die vielfältigen zur Thematik geführ-
ten Diskurse finden nur ausschnitthaft Eingang
in die Ihnen vorliegende Publikation.
Die Präsentation zeitgenössischer Kunst wird
in der Ausstellung durch drei historische Exkurse
ergänzt. Ein Raum widmet sich den Planspra-
chen. Sowohl Esperanto (1887 entwickelt von
Ludwik Zamenhof) als auch die internationale
Bildsprache Isotype (1925 entwickelt von Otto
Neurath), erzählen von dem Wunsch nach einer
antinationalen Welt ohne Übersetzung. Hierzu
hat Bernhard Tuider, Direktor des Esperantomu-
seums in Wien, einen Beitrag verfasst.
Ein weiterer Raum setzt sich mit der visuellen
und konkreten Poesie der 60iger und 70iger Jahre
auseinander. Er versammelt eine Auswahl an
Künstlerinnen, die Mirella Bentivoglio 1978 in
„Materializzazione del linguaggio" auf der Biennale
in Venedig zusammenführte. Eine wegweisende
Ausstellung, die dem weiblichen Blick auf Sprache
und der Übersetzung von Sprache in visuelle
Formen ein Forum gab und auf die die Kunsthis-
torikerin Anna Zinelli in ihrem Text für diese
Publikation Bezug nimmt.
Die angespannte politische Stimmung im Südtirol
der 70iger und 80iger Jahre wird in einer weiteren
Sektion der Ausstellung aufgegriffen. Das gesell-
schaftliche Klima der Jahre, das zwischen dem kul-
turpolitischen Leitgedanken Anton Zelgers
„Je klarer wir trennen, desto besser verstehen wir
uns" und in der verbindenden Erfahrung des kul-
turellen Schulterschlusses der verschiedenen Süd-
tiroler Sprachgruppen im besetzten Ex-Monopol
Gebäude ihre Antipode findet, wird in Textauszü-
gen der Südtiroler Politikerin und Schriftstellerin
Grazia Barbiero sowie des Südtiroler Lehrers
und Schauspielers Franco Bernard eingefangen.
Mein besonderer Dank gilt den Künstler*innen
der Ausstellung, den Autor*innen der Begleitpub-
likation sowie dem Team des Kunsthauses und
unseren Sponsor*innen.

Judith Waldmann, Kuratorische Leitung
Kunst Meran Merano Arte

INTRODUZIONE TRADUZIONE — UN PROCESSO MAGICO DA CUI SCATURISCE QUALCOSA DI NUOVO

JUDITH WALDMANN

"[...] what I consider to be one
of the most important arts of the future:
the art of translation."
Édouard Glissant (1928-2011)
Scrittore, poeta e filosofo

Con "The Poetry of Translation" Kunst Meran
Merano Arte indaga l'appassionante fenomeno
della traduzione. 30 importanti artisti e artiste,
nazionali e internazionali, propongono oltre 70
lavori capaci di far luce sul processo della tradu-
zione da prospettive inedite.
Traendo ispirazione dalla condizione multilingue
vissuta in Alto Adige e dalla sua complessa
storia di convivenza interetnica, Kunst Meran
Merano Arte si pone come il contesto ideale
per una mostra dedicata alla traduzione, che inten-
de porre interrogativi su concetti quali l'identità,
il multiculturalismo, la diversità.
La mostra collettiva guarda al complesso processo
della traduzione tanto in qualità di fonte di parte-
cipazione, comprensione internazionale, creatività,
genio e poesia quanto come possibile causa di in-
comprensioni ed esclusioni. La traduzione è intesa
come un processo creativo da cui scaturisce sem-
pre qualcosa di nuovo.
All'inizio del percorso espositivo, l'opera "Disputed
Utterance" (2019) dell'artista anglo-libanese
Lawrence Abu Hamdan rimanda a sette casi giudi-
ziari al centro dei quali si trovano forme di in-
comprensione. I diversi processi ruotano intorno
a domande come: l'istruttore spagnolo di bungee
jumping ha gridato "NOW JUMP" o "NO JUMP"
prima che uno dei suoi clienti compisse il salto
che si sarebbe rivelato fatale?
Opere video come "Classified Digits" (2016)
di Christine Sun Kim e Thomas Mader o "Answer
me" (2008) di Anri Sala esplorano le possibilità
di comunicazione interpersonale attraverso diversi
sistemi di segni, non esclusivamente verbali e lin-
guistici. Nel lavoro di Sala, la conversazione di rottu-
ra di una giovane coppia è condotta sia attraverso
la lingua sia attraverso la musica, con l'uomo che
non risponde verbalmente alle domande della
donna, ma suonando energicamente una batteria.
Sun Kim, sorda dalla nascita, traduce invece, assie-
me al suo partner, situazioni quotidiane come
"One person attempting to join a group conversa-
tion" con l'aiuto della mimica facciale e della ge-
sticolazione delle mani.
La presentazione del fenomeno della traduzione
è ampliata attraverso opere in cui, ad esempio,
la danza è trasformata in segnali luminosi prodotti
da 32 tubi al neon appesi verticalmente (Heid
und Griess, "Untitled", 2013) oppure la musica
è restituita come disegno (Jorinde Voigt, "Ludwig
van Beethoven / Sonate Nr. 1 bis 32", 2012).
Più questo processo diventa astratto, più emerge
l'aspetto poetico della traduzione.

Queste opere ci portano a confrontarci con codici
che – analogamente a una lingua straniera – non
possono essere decifrati direttamente. Sollevano
così domande relative al capire e al non capire,
al decodificare, ma anche all'immaginazione, alle
associazioni, alle interpretazioni e, in definitiva,
alla partecipazione così come a barriere ed esclusioni.
Come reagiamo quando ci troviamo di fronte
a un codice che non comprendiamo? Questa espe-
rienza, che può essere vissuta in mostra, prosegue
con la pubblicazione che la accompagna. Soltanto
i testi introduttivi sono stati tradotti in inglese,
italiano e tedesco mentre quelli dedicati alle opere
e la selezione di contributi teorici sull'argomento
sono riportati nella madrelingua degli autori
e delle autrici o nella forma originale con cui
erano stati pubblicati.
È importante sottolineare che le poche lingue,
esclusivamente europee, presenti nella pubblicazio-
ne rappresentano solo una frazione minima
delle oltre 7.000 lingue presenti al mondo; anche
i testi scelti sono solo una piccola selezione
dei numerosi discorsi presenti sull'argomento.
In mostra le ricerche contemporanee sono accom-
pagnate da tre excursus storici. Una sala è dedi-
cata alle lingue artificiali: tanto l'esperanto che
il linguaggio internazionale per immagini isotype
(sviluppati, rispettivamente, nel 1887 da Ludwik
Zamenhof e nel 1925 da Otto Neurath) ci raccon-
tano il desiderio di un mondo antinazionale e senza
traduzioni. Una seconda sala si confronta con
la poesia visiva e concreta degli anni '60 e '70, dando
spazio – in particolare – a un gruppo di artiste
che erano state riunite da Mirella Bentivoglio nella
mostra "Materializzazione del Linguaggio", realiz-
zata in occasione della Biennale di Venezia del 1978.
Questa mostra innovativa, a cui fa riferimento
la storica dell'arte Anna Zinelli nel suo contributo
in questa pubblicazione, ha dato spazio alla visio-
ne femminile del linguaggio e alla traduzione del
linguaggio in forme visive.
Un'altra sezione della mostra si sofferma invece
sulle tensioni politiche nell'Alto Adige degli anni
'70 e '80. Il clima sociale di quegli anni vede
contrapporsi al principio politico culturale di Anton
Zelger "Più ci separiamo e più ci capiamo"
e l'esperienza di alleanza culturale tra i diversi
gruppi linguistici nell'occupazione dell'ex
Monopolio. Questo periodo è restituito attraverso
due estratti, uno della politica e scrittrice altoa-
tesina Grazia Barbiero e uno dell'insegnante e atto-
re altoatesino Franco Bernard.
Vorrei ringraziare in particolare gli artisti e le artiste
presenti in mostra, gli autori e le autrici della pub-
blicazione, il team della Kunsthaus e i nostri sponsor.

Judith Waldmann, Curatrice responsabile
delle mostre di arte contemporanea
Kunst Meran Merano Arte

INTRODUCTION TRANSLATION — A MAGICAL PROCESS THAT RESULTS IN SOMETHING NEW

JUDITH WALDMANN

"[...] what I consider to be one of the most important arts of the future: the art of translation."
Édouard Glissant (1928-2011)
Writer, poet and philosopher

With "The Poetry of Translation", Kunst Meran Merano Arte is investigating the compelling phenomenon of translation. Over 70 works by over 30 national and international artists shed light on the process of translation from novel perspectives. Inspired by the living multilingual environment of South Tyrol and its eventful history of interethnic cohabitation, Kunst Meran Merano Arte offers the ideal context for an exhibition dedicated to translation and questions surrounding identity, multiculturalism and diversity.

The group show addresses translation in its complexity: on the one hand, as a source of inclusion, international understanding, creativity, genius and poetry, while on the other as a cause of misunderstanding and exclusion. It is understood here as a creative process through which something new is always created.

Starting from the translation of one language into another, the exhibition opens out into the transfer of other (artistic) sign systems, such as music, song, dance, colour, light, digital codes or painting. At the beginning of "The Poetry of Translation", "Disputed Utterance", a 2019 work by the British-Lebanese artist Lawrence Abu Hamdan, takes seven legal cases where misunderstandings lay at the core. The respective lawsuits revolve around such questions as: Did a Spanish bungee jump instructor shout "NOW JUMP" or "NO JUMP" before one of his clients plunged to death?

Video works such as "Classified Digits" (2016) by Christine Sun Kim and Thomas Mader, or "Answer me" (2008) by Anri Sala, go further and explore the possibilities of interpersonal communication within different – and not exclusively verbal-linguistic – sign systems. The break-up conversation of a young couple in Sala's work is conducted in both language and music: rather than responding verbally to the woman's questions, the man replies with energetic drum rolls. On the other hand Sun Kim, who was born deaf, translates everyday situations together with her partner, such as: "One person attempting to join a group conversation", with the help of facial expressions and hand gesticulations.

The presentation of the phenomenon of translation is expanded to include works in which, for example, dance is translated into light signals by means of 32 vertically-dangling neon tubes (Heid and Griess, "Untitled", 2013), or music into drawing (Jorinde Voigt, "Ludwig van Beethoven – Sonatas 1 to 32", 2012): matters become more abstract and the poetic moment of translation comes to the fore.

These artistic works confront us with codes that, like a foreign language, cannot be directly deciphered. They raise questions of understanding and not understanding, of decoding, but also of imagination, association and interpretation – and ultimately about inclusion, as well as barriers and exclusion.

How do we react when confronted with a code that we do not understand? This sensation, which can be experienced in the exhibition, is continued in the accompanying publication. Only the introductory texts are translated into English, Italian and German. The texts for the works, as well as the selection of theoretical remarks on the subject, are printed untranslated in the first language of the authors or in the original language of the respective texts.

It is important to note that the few, exclusively European languages that appear in the publication represent only a tiny fraction of the more than 7,000 languages spoken worldwide – and that this publication only contains some excerpts of the many discourses on the topic.

The presentation of contemporary art in the exhibition is complemented by three historical digressions. One room is dedicated to "planned" languages: both Esperanto (developed in 1887 by Ludwik Zamenhof) and the international pictorial language Isotype (developed in 1925 by Otto Neurath) reflect a desire for an anti-national world where translation is not required. Bernhard Tuider, director of the Esperanto Museum in Vienna, has submitted a contribution on this subject.

Another room addresses the visual and concrete poetry of the 1960s and 1970s, bringing together a selection of artists gathered by Mirella Bentivoglio in "Materializzazione del linguaggio" at the Venice Biennale in 1978, a groundbreaking exhibition that provided a forum for the female view of language and the translation of language into visual forms: art historian Anna Zinelli makes reference to this in her article for this publication.

The tense political atmosphere in South Tyrol in the 1970s and 1980s is dealt with in another section of the exhibition. The social climate of those years, divided between the guiding cultural and political principle of Anton Zelger, namely "The more clearly we separate, the better we will understand each other", and its converse, the unifying experience of the cultural solidarity demonstrated by the various South Tyrolean language groups in the occupied former Monopol building, is captured in excerpts from the works of the South Tyrolean politician and writer Grazia Barbiero and the South Tyrolean teacher and actor Franco Bernard.

My special thanks go to the artists participating at the exhibition, to the authors of the accompanying publication, to the Kunsthaus team and to our sponsors.

Judith Waldmann, Chief Curator,
Kunst Meran Merano Arte

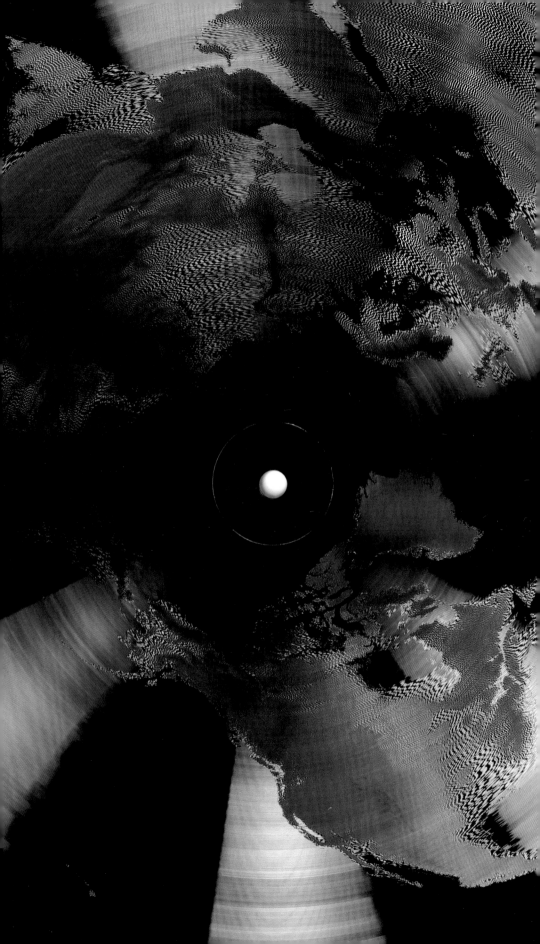

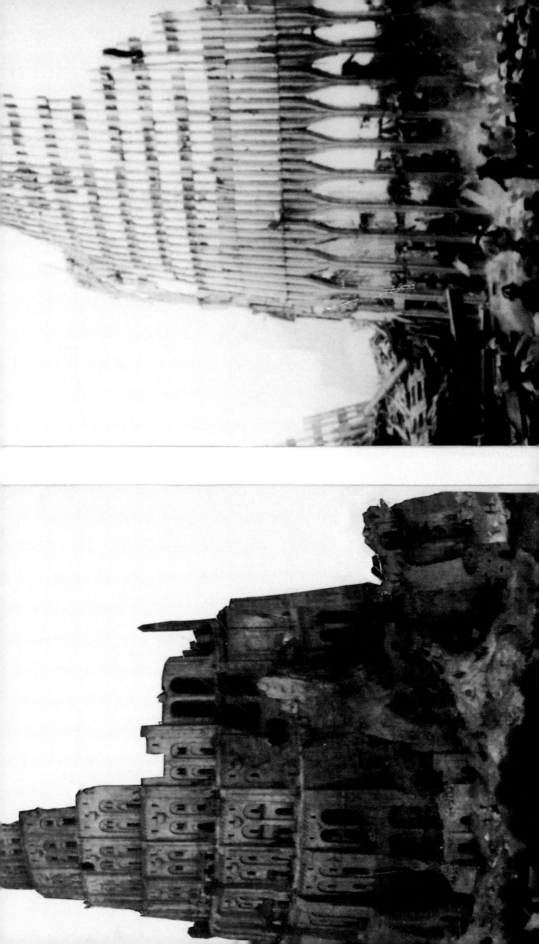

how many languages you are speaking?

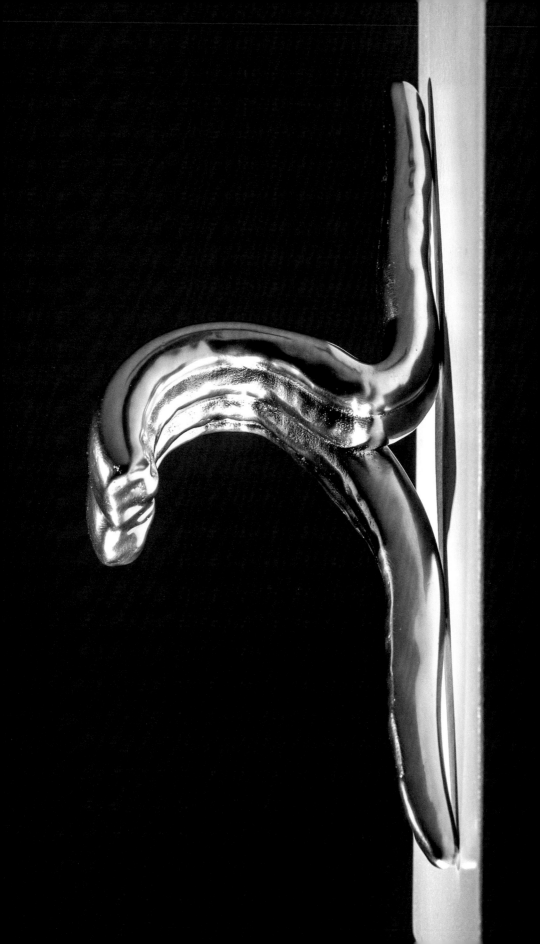

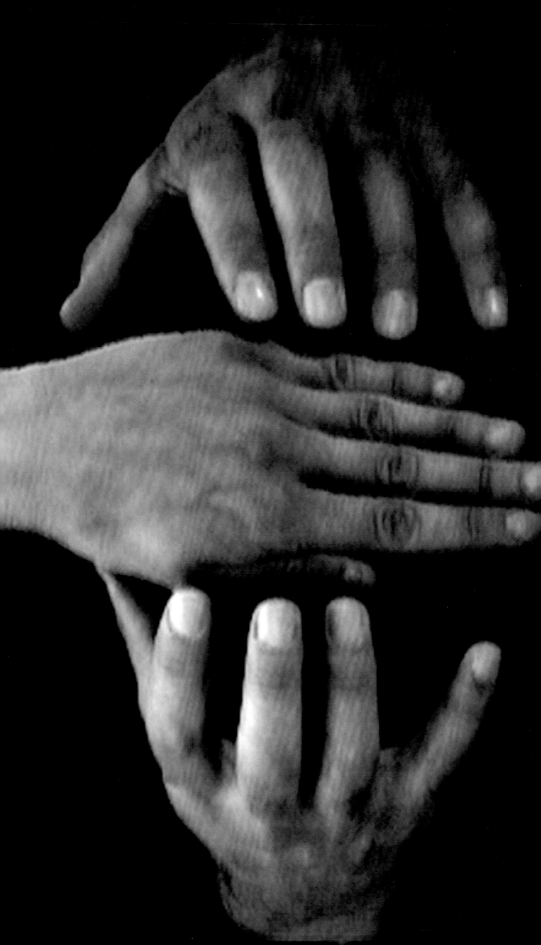

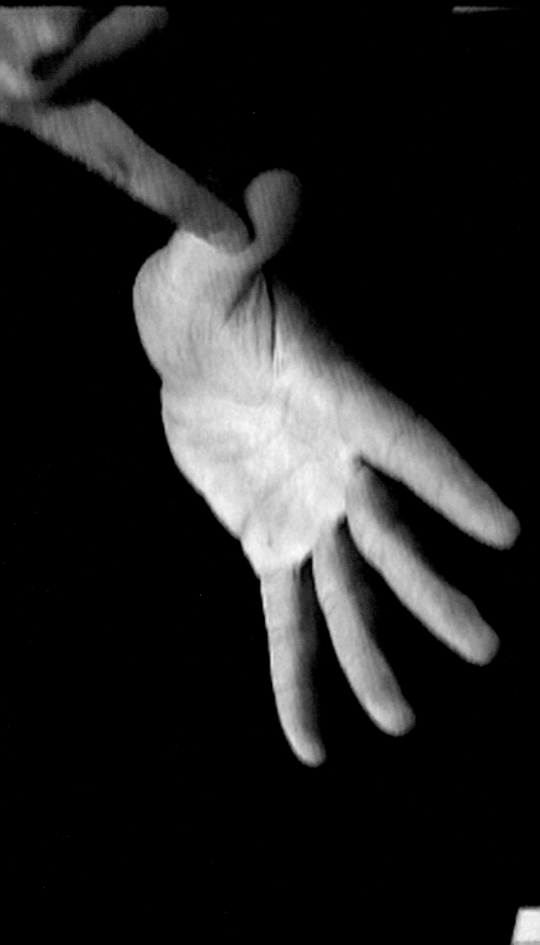

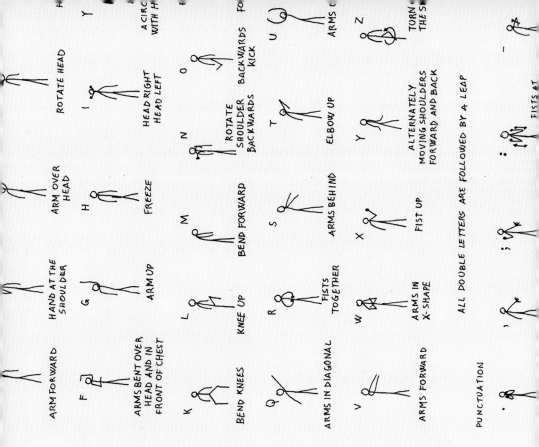

FOUND DANCE | ALL!

LEARN THE GESTURAL ALPHABET BY HEART
PUT A POEM IN YOUR MIND
TRANSLATE THE POEM WITH THE NEW ALPHABET
FEEL FREE TO MOVE IN THE SPACE
TO PRONOUNCE SOME LETTERS
TO FOLLOW YOUR OWN RHYTHM

KINKALERI 2015/2021

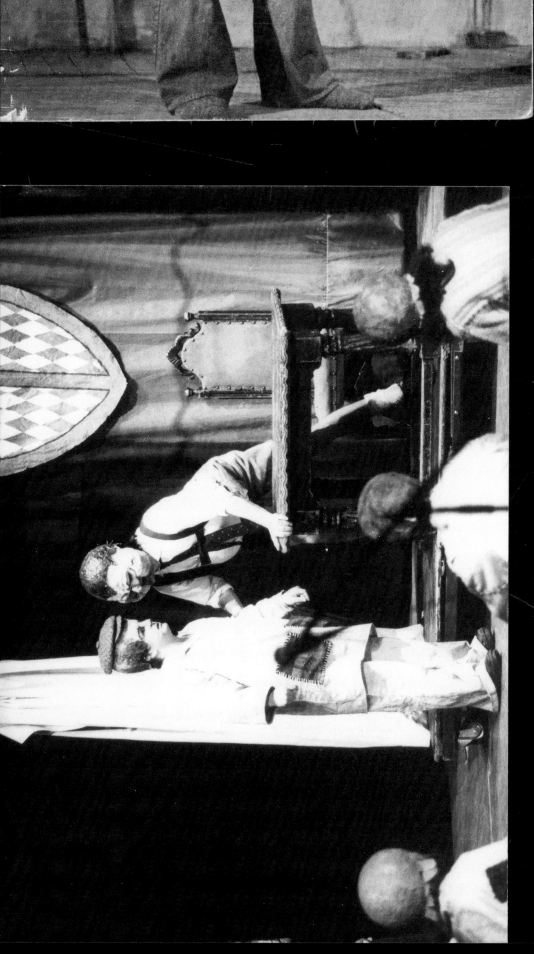

Mächte der Erde

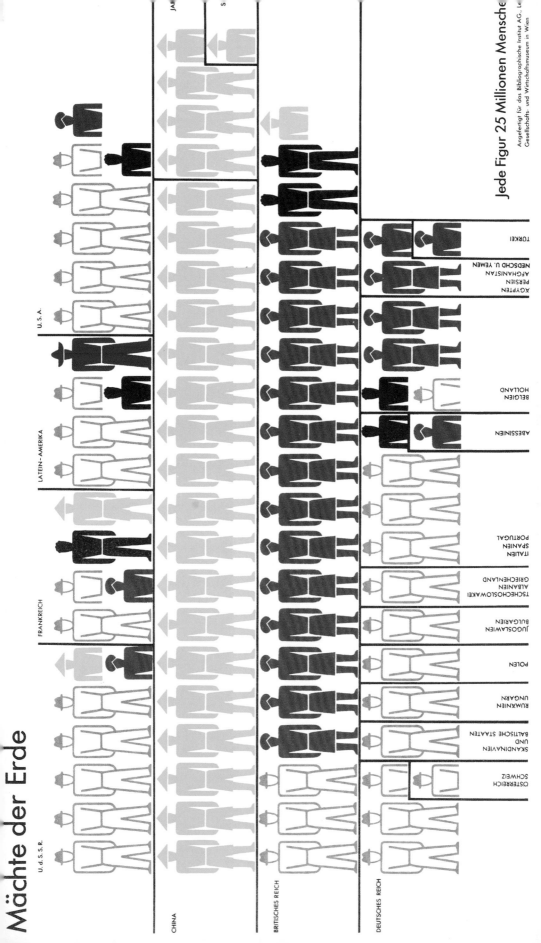

Jede Figur 25 Millionen Menschen

Angefertigt für das Bibliographische Institut AG., Le[...]
Gesellschafts- und Wirtschaftsmuseum in Wien

U.d.S.S.R.

CHINA

JAP[...]

S[...]

U.S.A.

LATEIN-AMERIKA

FRANKREICH

BRITISCHES REICH

DEUTSCHES REICH

TÜRKEI

ÄGYPTEN
PERSIEN
AFGHANISTAN
NEDSCHD U. YEMEN

HOLLAND
BELGIEN

ABESSINIEN

ITALIEN
SPANIEN
PORTUGAL

TSCHECHOSLOWAKEI
ALBANIEN
GRIECHENLAND

JUGOSLAWIEN
BULGARIEN

POLEN

RUMÄNIEN
UNGARN

SKANDINAVIEN
UND
BALTISCHE STAATEN

ÖSTERREICH
SCHWEIZ

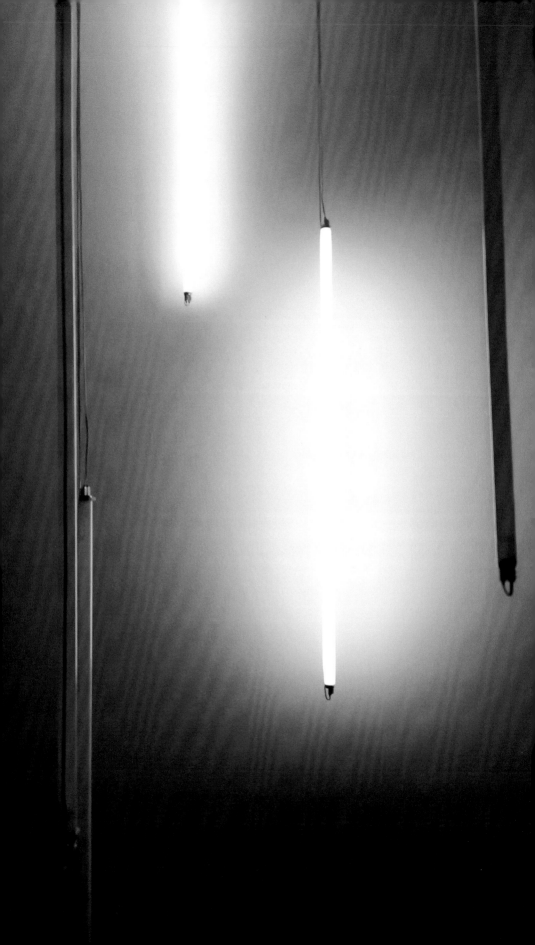

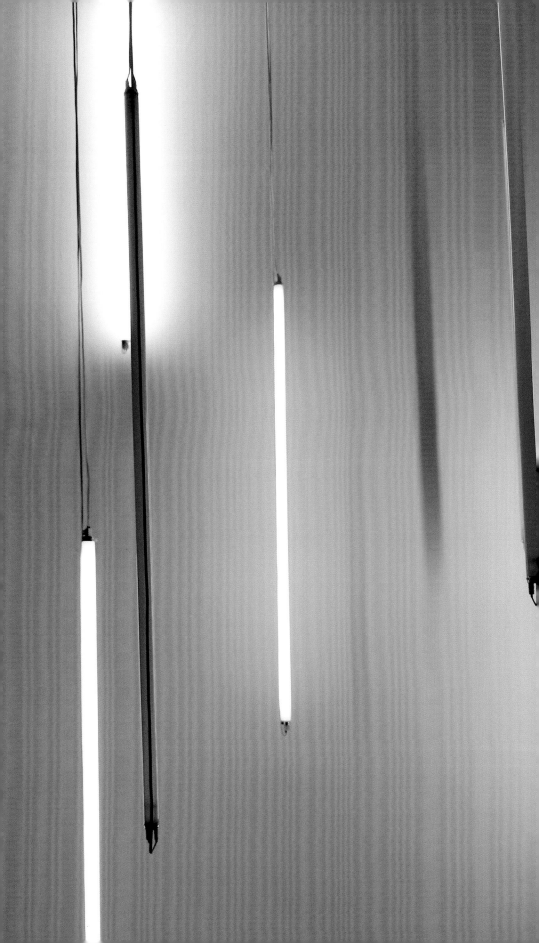

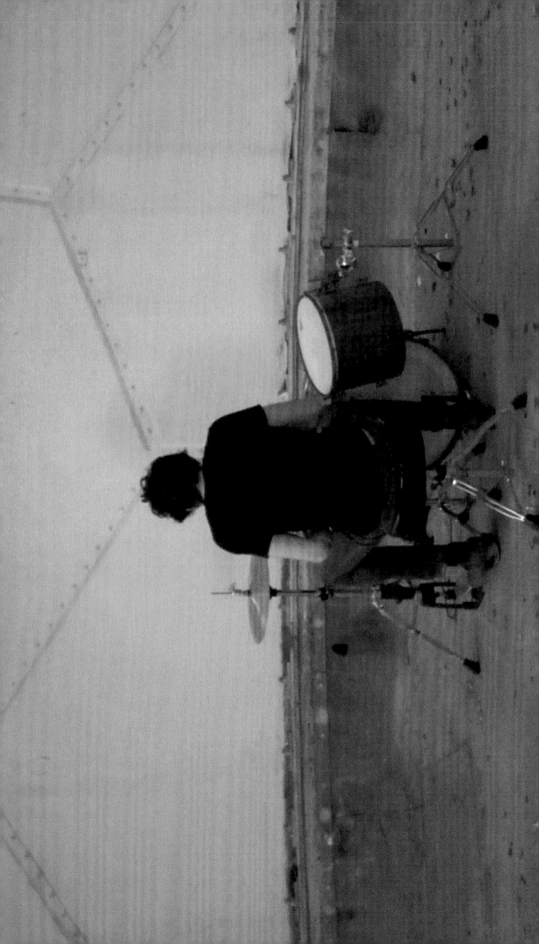

KATJA AUFLEGER (*1983, Oldenburg, Germany)
SUM OF ITS PARTS, 2012
Sounds on vinyl record,
A-side northern hemisphere, B-side southern hemisphere, 2 × 20'
Courtesy: the artist, STAMPA Gallery, Basel and Conradi Gallery, Hamburg / Brussels

The record titled "SUM OF ITS PARTS" (2012) spins continuously on the turntable. It produces peculiar sounds - rhythmically purring, whistling, and scratching. Light reflections on the record draw the eye to the outlines of the five continents and, like the record cover, hint at what is setting the tone. It's the Earth, with the Northern Hemi–sphere on the A side of the vinyl and the South-ern Hemisphere on the B side. When played, the stylus travels in a spiral from the equator to the pole in 530 revolutions, spinning around the earth 33 times per minute, making one re-vo-lution in 1.8 seconds. The different elevations of the earth's surface were translated into fre-quencies. One meter above sea level corresponds to one hertz. Mount Everest is thus the highest audible sound, and the sea provides the pauses. (Carla Brunke)

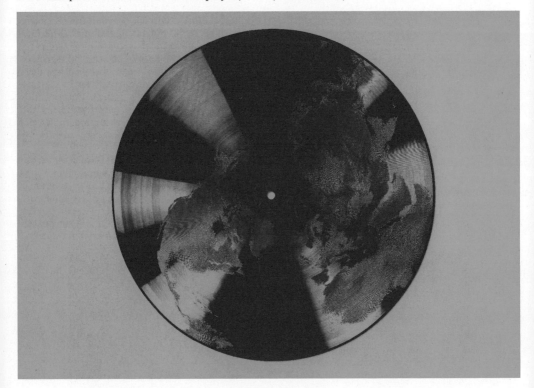

FANTASIA TYPE (MICHELE GALLUZZO [*1985, Francavilla Fontana, Italia] & FRANZISKA WEITGRUBER [*1992, Sud Tirolo, Italia]) MIND YOUR LANGUAGE, 2021
Pellicola su pavimento, 92 × 12 cm
Courtesy: the artists

"Mind your language": è questa l'esortazione nella quale ci si imbatte – letteralmente – all'ingresso del percorso espositivo. Tradotta dall'inglese significa "bada al tuo linguaggio", un concetto che si adatta a molte delle opere esposte in mostra. Michele Galluzzo e Franziska Weitgruber hanno deciso di apporlo sul pavimento della galleria sotto forma di una scritta simile a quelle che, sulle banchine ferroviarie, consigliano ai passeggeri di tenersi a distanza dai binari. Camminandoci sopra il visitatore ha l'impressione di varcare un confine, e al tempo stesso prende atto di un ammonimento posto a rimarcare l'importanza delle parole e delle modalità d'espressione – una tematica molto dibattuta in questo periodo, specie per quanto riguarda le questioni di genere. (Federica Bertagnolli)

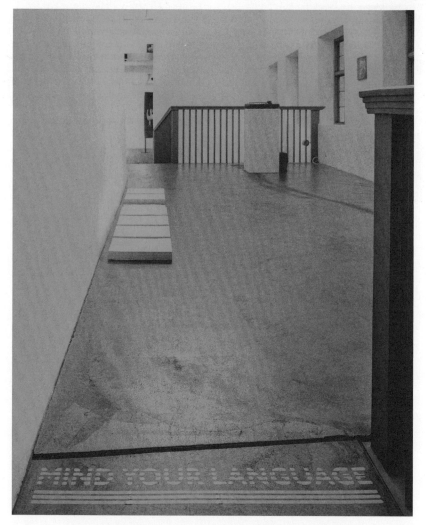

BABI BADALOV (*1959, Lerik, Azerbaijan)
VISUAL TEXTUAL POETRY, 2021
Painting on fabric, Wall painting, 152 × 112 cm
Courtesy: the artist, Gallery Jérôme Poggi, Paris and The Gallery Apart Rome

Babi Badalov's visual poetry is characterized by the experience of migrant life, where the learning, understanding, and misunderstanding of language is a constant and central struggle. Cyrillic and Latin characters seamlessly merge into pictorial collages, turning fragments of French, Russian, and English into an idiosyncratic language that follows a phonetic rather than a grammatical or orthographical logic, and in so doing delivers ironic political commentary that is both radical and playful. Born in the small town of Lerik in Azerbaijan, near the Iranian border, the artist would come to embark on an odyssey through different cities of the Western world, partially as a paperless refugee. The languages and situations Badalov encountered along the way are woven into a fragmented audiovisual tapestry, which the artist then reassembles into site-specific installations that trace a human existence on the edges of society. Badalov's collages ridicule governmental policies as well as social and political events that reflect the experience and struggle of seeking asylum and trying to integrate, exposing their lack of logic and humanity. The humorous tone only thinly veils the serious examination of language, barriers, borders, nationality, normality, queerness, and exclusion that lies at the works' core. The linguistic and pictorial ruminations traverse Eastern and Western thought systems, contemplating the current geopolitical situation while relating it to personal predicaments of migrant life. If the Tower of Babel marked the end of a universal language and a united human race, then perhaps Badalov's understanding of the world is both a painful reminder of when "the whole earth was of one language, and of one speech" (Genesis 11:1) as well as a glimpse of a possible return. (Reprint: Laura Amann, "Babi Badalov" in *And if I devoted my life to one of its feathers?*, Kunsthalle Wien (Ed.), Wien 2021, S. 24-25.)

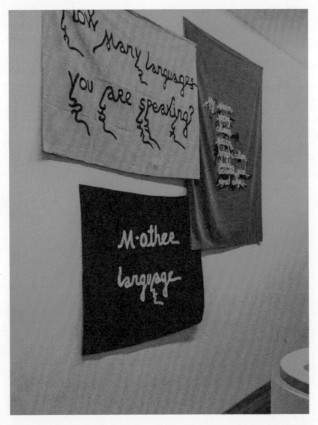

LAWRENCE ABU HAMDAN (*1985, Amman, Jordan) DISPUTED UTTERANCE, 2019
14 laser-cut dioramas, c-prints mounted on cardboard with wooden cases, 7 texts printed on plexiglas plates
Courtesy: the artist, mor charpentier, Maureen Paley and Sfeir-Semler Gallery

"Disputed Utterance" tell[s] seven stories of what is legally known as cases of "disputed utterances"; a trial where someone's culpability or innocence is hinged upon conflicted claims over a recorded word or phrase: did the bungee jump instructor say "no jump" or "now jump"? Did the doctor instruct his patient that he "can" or "can't" take the medicine? Did the British-Caribbean man with a strong accent say that he "shot a man to kill" or that he "showed a man ticket"? Each of these brief moments of critical misunderstandings and misinterpretations are rendered as three dimensional lifesized dioramas of the different shapes that these words print onto the palate, accompanied by short texts explaining the cases. (Reprint: Galerie mor charpentier, Paris: Lawrence Abu Hamdan, Artist Portfolio.)

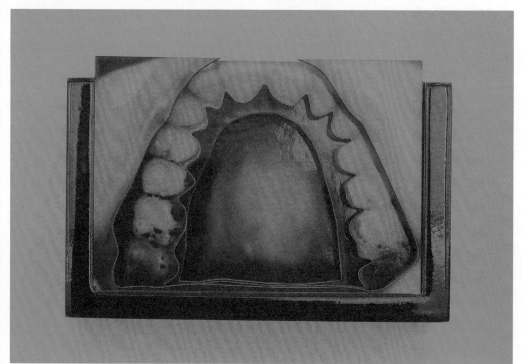

CHRISTINE SUN KIM (*1980, Orange County, Kalifornien) & THOMAS MADER (*1984, Süddeutschland)
CLASSIFIED DIGITS, 2016
Einkanal-Video, 5'28"
Courtesy: the artists and François Ghebaly Gallery, Los Angeles / New York

„Helping hands" ist ein beliebtes Improvisationsspiel, bei dem die Arme des einen Spielers hinter dem Rücken versteckt sind und durch die Arme des anderen Spielers ersetzt werden. In der fünfminütigen Videoarbeit „Classified Digits" (2006) schlüpfen Christine Sun Kim und Thomas Mader in diese Rollen: Mader „leiht" Sun Kim seine Arme, während sie seine Gesten durch Mimik ergänzt. Das Künstlerduo spielt dabei kurze, alltägliche und – oft auch leicht peinliche – Szenarien nach, die jedem bekannt sind – etwa die Begegnung zweier Fremder im Fahrstuhl oder einen Skype-Versuch mit schlechter Internetverbindung. Sun Kim, die gehörlos geboren wurde, „übersetzt" die Handbewegungen von Mader lediglich mit ihren Gesichtsausdrücken. Die beiden üben so jeweils nur einen Teil eines ASL-Gesprächs (American Language Sign) aus und bringen dabei unterschiedliche Fähigkeiten mit: Sun Kim ist Muttersprachlerin der amerikanischen Gebärdensprache, Mader ASL-Lernender. Sun Kims aufgerissene Augen, gespitzte Lippen oder hochgezogene Augenbrauen ergeben zusammen mit Maders erhobenem Zeigefinger – dem Zeichen für *eine* Person in ASL – eine kleine Geschichte, die durch ihren subtilen Humor besticht. Das Künstlerduo erschafft so eine eigene Sprache, die als Universalsprache fungiert – unabhängig von Gehörlosigkeit oder Fremdsprachen – und demonstriert gleichzeitig die komplexen Nuancen der gehörlosen Kommunikationslandschaft. Die Handzeichen und Fingerbewegungen – für ein nicht taubes Publikum oft der sichtbarste Teil der Gebärdensprache – sind nur der Anfang dieser Sprache: Mehr als die Hälfte von ASL wird durch das Gesicht und nicht durch manuelle Gesten übertragen. Die Handbewegungen dienen dabei als Klassifikator, um Typ, Form und Größe zu kennzeichnen, während die Mimik die Bedeutung eines bestimmten Zeichens dramatisch verändern oder weiter kontextualisieren kann.

Seit sechs Jahren arbeiten Christine Sun Kim und Thomas Mader zusammen an Werken, die den Betrachter dazu anregen, über die Reichtümer und Grenzen der zeitgenössischen Kommunikation nachzudenken, insbesondere über die Machtverhältnisse zwischen Gebärdensprachen und gesprochenen Sprachen. Dabei schafft „Classified Digits" das, was in der Realität häufig misslingt: Eine Brücke zwischen Gehörlosen und Nichtgehörlosen zu bauen und die Gemeinsamkeiten beider Gruppen zu unterstreichen, anstatt ihre Unterschiede hervorzuheben.
(Felicitas Schwanemann)

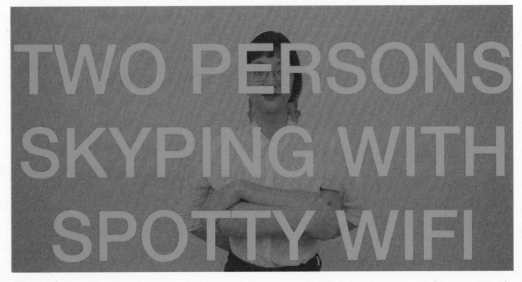

SIGGI HOFER (*1970, Bruneck, Italien)
I AM, 2012
Acryl und Bleistift auf Leinwand, 100 × 100 cm
Courtesy: the artists and Autonome Provinz Bozen, Südtirol – Provincia Autonoma di Bolzano, Alto Adige

Schrift und Text sind zentrale Bausteine der Arbeiten von Siggi Hofer. Dabei werden Inhalte auf einer vieldeutigen Ebene zur Disposition gestellt, um herkömmliche Sinnzusammenhänge zu hinterfragen. Die Textarbeit „I am from Cadipietra" (2012) spielt auf die Herkunft des Künstlers aus Steinhaus im Ahrntal an. Durch das Englische „I am from" in Kombination mit der italienischen Version des Namens der Ortschaft Steinhaus werden unterschiedliche Bedeutungsschichten sozialer, politischer und rechtlicher Natur übereinander gelagert, sodass die tatsächliche Komplexität dieser scheinbar so einfachen Aussage akzentuiert wird. (Nachdruck: Sabine Gamper, *Arbeiten. Lavori in corso, Kunstankäufe. Acquisti di opere d'arte. 2012–2018*, Autonomen Provinz Bozen-Südtirol, Abteilung Deutsche Kultur - Provincia autonoma di Bolzano-Alto Adige, Ripartizione Cultura tedesca, Bozen/Bolzano 2020, S./p. 86-87.)

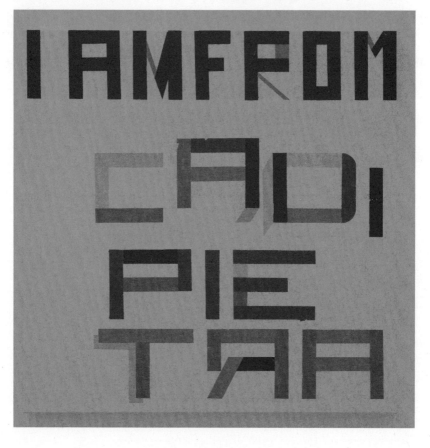

SLAVS AND TATARS (*Founded in 2006 from Kasia Korczak and Payam Sharifi)
ALPHABET ABDAL, 2015
Woolen yar, 190 × 495 cm
Courtesy: the artists and Kraupa-Tuskany Zeidler Gallery, Berlin

The thematic focus of Slavs and Tatars is upon languages, scripts and alphabets, which they deem to be far from neutral or innocent entities but rather the handmaidens of empires, religions and political powerplays. Thus, the carpet "Alphabet Abdal" (2015) features script in Arabic that roughly translates as "Jesus, son of Mary, he is love". Inextricably linked with Islam, this script refers here to the basic tenets of Christianity, which was itself, in its early incarnation, closely connected to the Arabic alphabet. (Reprint: Kristina Scepanski, Slavs and Tatars, *Saalbadereien/ Bathhouse Quackeries*, Westfälischer Kunstverein, Münster 2018.)

SZPAGAT, 2017
Chromierte Bronze, 11 × 28 × 5,6 cm
Courtesy: the artists and Kraupa-Tuskany Zeidler Gallery, Berlin

„Mutterzunge" lautet die wortwörtliche Übersetzung von englisch „Mother Tongue" für Muttersprache oder Erstsprache. Ein Begriff, der in der bronzenen Plastik des Künsterkollektivs „Slavs and Tatars" seine Visualisierung gefunden hat. Die personifizierte Zunge erinnert in ihrer geschwungenen Form an eine Ballerina oder einen Ballerino, welche*r mit Eleganz ein Spagat aufführt. Gespalten steht sie für multiple (Mutter-) Sprachen und damit einhergehend für multiple Kulturen. Im Kontext von Südtirol, mit seinen drei offiziellen Amtssprachen, ruft „SZPAGAT" neue Bezüge auf. Hier in Meran scheint die Plastik vom interethnischen Zusammenleben in der Region zu erzählen – davon wie ihre Bewohner*innen den Spagat schaffen zwischen den verschiedenen Sprachgruppen, die weit über das Italienische, Deutsche und Ladinische hinausgehen. (Judith Waldmann)

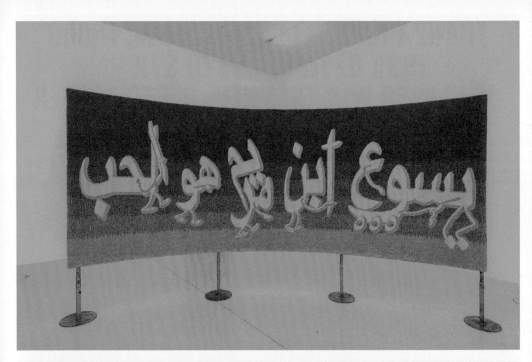

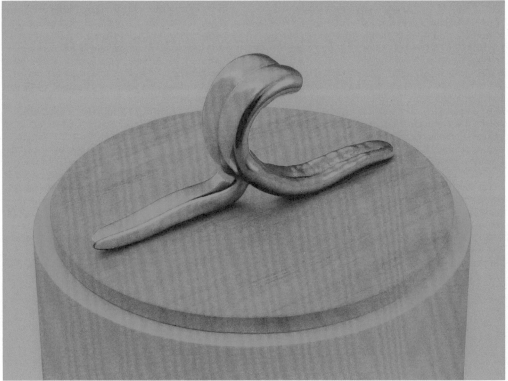

FRANZ PICHLER (*1939, Scena, Italia)
1939 OPTION – 1979 SVP –
JE KLARER WIR TRENNEN, DESTO BESSER
VERSTEHEN WIR UNS!, 1979
Serigrafia monocromatica,
70 × 100 cm,
Courtesy: the artist

Nota preliminare: Il controverso passo di Zelger, risalente al 1979, non rispecchia le attuali posizioni della Südtiroler Volkspartei. Nel suo contributo, Grazia Barbiero affronta la complessa situazione politica dell'Alto Adige negli anni '70 e '80.

Separati a scuola

Il 1979 aveva registrato un fatto emblematico.[1] L'intendente alle scuole in lingua tedesca, David Kofler, aveva bruscamente interrotto gli scambi tra studenti del liceo scientifico in lingua tedesca e di quello in lingua italiana, situati a pochi metri l'uno dall'altro, nello stesso nuovo complesso riservato da poco tempo agli istituti superiori e alle scuole medie della seconda città del territorio, in via Karl Wolf, un lunghissimo viale di tigli tra Merano e Lagundo. La Svp aveva lanciato contro la popolazione scolastica un'accusa pesante: secondo il grande partito di raccolta, studenti e insegnanti si stavano lasciando strumentalizzare da una macchinazione comunista.[2] Gli studenti meranesi avevano protestato compatti. Italiani e tedeschi erano scesi a Bolzano, il 9 marzo, per manifestare in piazza e dopo pochi giorni, il 20 e il 21 marzo, si erano seduti sulle tribune del pubblico in Consiglio provinciale. In quell'occasione istituzionale, l'assessore alla Scuola e alla Cultura in lingua tedesca, Anton Zelger, aveva sintetizzato la sua filosofia con memorabili parole che hanno lasciato una traccia profonda nella storia di questa terra: "Noi siamo per una società in cui ciascuno sia padrone fino in fondo della sua propria lingua e nello stesso tempo ne impari una seconda per quel tanto che gli serve. Dirò di più: i diversi gruppi linguistici tanto meglio si capiranno quanto più saranno separati". Un immediato boato di protesta degli studenti, stipati in piccionaia, aveva fatto comprendere cosa i ragazzi pensassero di quella diagnosi politica, più simile a una falce che a un ordine praticabile (...).

Il gruppo dirigente della Südtiroler Volkspartei aveva, ancora una volta, sbattuto la porta in faccia alla parte dialogante, progressista, della società, sia di lingua italiana che tedesca. Il giorno successivo al dibattito appena concluso nell'aula del Consiglio provinciale, studenti e insegnanti dei due licei scientifici meranesi avevano trovato sbarrato il cancello che divideva i due cortili. Non era più possibile incontrarsi nemmeno per i pochi minuti della pausa. Era la prima volta che succedeva. (Ristampa: Grazia Barbiero, *Scenari in movimento. Gli anni settanta e ottanta in Alto Adige / Südtirol*, Edition Raetia, Bolzano 2021, pp. 52-54.)

1
Fabio Levi, *In viaggio con Alex. La vita e gli incontri di Alexander Langer (1946-1995)*, pag. 81, Giangiacomo Feltrinelli Editore, Milano 2007.
2
Maurizio Ferrandi, "La profezia di Anton", "salto.bz", 9 marzo 2019.

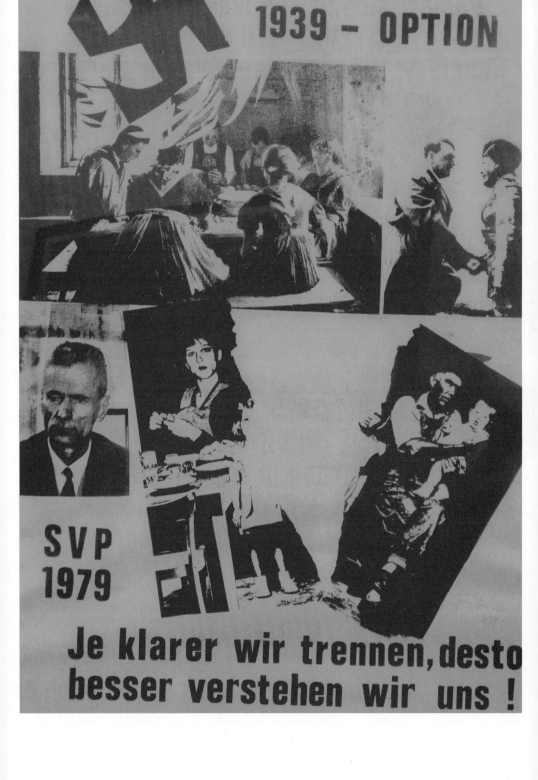

LENA IGLISONIS
OHNE TITEL, 1980
Papier; Siebdruck: Jakob de Chirico, 100 × 70 cm
Courtesy: the artist and Walter Bernard

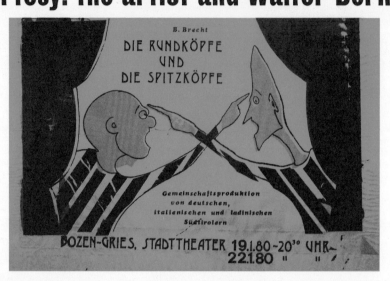

FRANCO MARINI (*1935, †2014, Meran, Italien)
DIE RUNDKÖPFE UND DIE SPITZKÖPFE, 1980
Theateraufführung in Meran, Fotografie, Variable Maße, Mit freundlicher Genehmigung der Familie Marini

Was für ein Theater?! Eine Bestandsaufnahme

Im Herbst 1979 wurde das leerstehende Monopolgebäude in Bozen durch verschiedene Kulturinitiativen besetzt und einen Monat lang gehalten.[1] Aus dieser intensiven Begegnung ging ein Theaterstück hervor, das Furore machen sollte. Unter der [...] Regie von Götz Fritsch wurde mit rund 75 Mitwirkenden Bert Brechts „Die Rundköpfe und die Spitzköpfe" (1931-34) auf die Bühne gebracht.[2] Das Stück ging im Januar 1980 auf Tournee. Das Außerordentliche – für manche Bemerkenswerte,[3] für andere Brandgefährliche[4] – an der Inszenierung: Im Ensemble waren alle drei lokalen Sprachgruppen vertreten. Die Rundköpfe sprachen Deutsch, die Spitzköpfe Italienisch. Der Erfolg beim Publikum und das mediale Echo waren außerordentlich.[5] In Meran konnte die Aufführung diesmal sogar im Stadttheater angeboten werden. Dominikus Andergassen, Mitglied der Theatergruppe, erinnert sich: *„Die Aufführung im Meraner Stadttheater ist wegen einer fast einstündigen Verspätung des Beginns noch zusätzlich erwähnenswert, da die Feuerwehr (ihre Sorge um die Sicherheit von Mensch und Struktur war durchaus berechtigt) den Saal wegen hoffnungsloser Überfüllung zu räumen drohte. Es kam dann dank eines Kompromisses doch noch zur Aufführung, die aber entsprechend spät zu Ende ging – das Stück dauerte immerhin fast drei Stunden."[6]* (Nachdruck: Franco Bernard, „Was für ein Theater?! Eine Bestandsaufnahme" in Markus Neuwirth, Ursula Schnitzer (Hrsg.), *Kultur in Bewegung*, Meran 2021, S./p. 147-166; 157.)

1

Elfi Reiter (2.1.2020). Ex Monopolio occupato - un libro, in: www.salto.bz: https://www.salto.bz/de/article/02012020/ ex-monopolio-occupato-un-libro?utm_source=salto&utm_ campaign=3148ad8238-E-MAIL_CAMPAIGN_2019_10_25_02_ 24_COPY_01&utm_medium=email&utm_term=0_ 774542d048-3148ad8238-80740125.

2

„Lo spettacolo regge perfettamente insomma (...) e raggiunge il suo duplice scopo: quello di divertire (e lo hanno dimostrato gli applausi continui) e quello di far riflettere sulle strumentali distorsioni del nazionalismo. È un peccato perderlo: dovrebbero vederlo (e meditarci) tutti, In Alto Adige." (Gandini, 1980) zitiert nach Solveig Freericks, Franz Pichler, Isolde Tappeiner (Hg.), *Südtiroler Kulturzentrum. Der Alltag ist unsere Kultur*, Meran 2000, op.cit., S. 185f.

3

„Scheinheilig wird dieser Brecht in einer ‚versöhnlichen' Sprachmixtur aus den drei Landessprachen serviert – und gleichzeitig wird ein Manöver inszeniert, um die Brandfackel der Zwietracht unter die Jugend zu werfen." (-ld, 1980) zitiert nach Freericks, Pichler, Tappeiner, 2000, op.cit., S. 188.

4

„(Es) war sicher das einzige jemals in Südtirol inszenierte Theaterstück, das es in die Fragestunde des italienischen Parlaments und in die Kulturnotizen des ersten deutschen Fernsehsenders ARD geschafft hat." Dominikus Andergassen, „Man tut sich heute schwer", in: Dominikus Andergassen, Paolo Crazy Carnevale, Martin Hanni, *Occupato „ex Monopolio" in via Dante- Str. 6 Besetzt. 40 anni dopo – 40 Jahre danach*, Meran 2019.

5

Dominikus Andergassen, „Man tut sich heute schwer", in: Dominikus Andergassen, Paolo Crazy Carnevale, Martin Hanni, Occupato „ex Monopolio" in via Dante- Str. 6 Besetzt. 40 anni dopo – 40 Jahre danach, Meran 2019.

6

Ibidem

BEN VAUTIER (*1935, Neapel, Italy)
ETHNIES EN LUTTE, 1979/1990
Silkscreen on cloth, Edition of 50, 118 × 161 cm
Francesco Conz Editions
Courtesy: Archivio Conz, Berlin

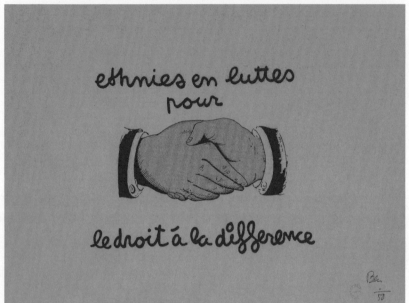

ESPERANTO GLOBAL EXHIBIT, 1945
Nachdruck, 55 × 35,5 cm Courtesy:
Sammlung für Plansprachen
und Esperantomuseum, Österreichische
Nationalbibliothek

Esperanto – eine Welt ohne Übersetzung?

Esperanto ist die weltweit bekannteste Plansprache und wird in der Gegenwart in mehr als 100 Ländern von mehreren zehntausend Menschen gesprochen. Für ihren Initiator Ludwik Lejzer Zamenhof war Sprachenvielfalt eine gelebte Wirklichkeit und eine wichtige Inspirationsquelle. Aufgewachsen in der multikulturellen Stadt Białystok erlebte er bereits als Kind, dass Sprachen auch Hindernisse für die Verständigung bilden können. Mit dem Ziel Kommunikationsbarrieren zu überwinden, begann er deshalb schon als Jugendlicher eine transnationale Sprache auszuarbeiten. Das erste Esperanto-Lehrbuch „Lingvo Internacia" veröffentlichte er aber erst 1887 nach dem Abschluss seines Medizinstudiums. Esperanto verbreitete sich relativ rasch, so dass Émile Boirac, Professor für Philosophie und Rektor der Universität Dijon, 1908 in einem Brief an Wilhelm Ostwald, den späteren Nobelpreisträger für Chemie schreiben konnte: „Laŭ ni [Esperanto-parolantoj] Esperanto estas lingvo jam ekzistanta, vivanta, simila en tiu rilato al naturaj kaj naciaj lingvoj, angla, franca, germana, k.t.p. Gi estas konsekvence kiel ili fakto kaj eĉ fakto sociala, kiu evolucios, same kiel ĉiuj socialaj faktoj, [...].“[1]

Bereits das erste Buch „Lingvo Internacia" enthält zwei original in Esperanto verfasste Gedichte: „Mia penso" sowie „Ho, mia kor'" von Ludwik L. Zamenhof und seine Übersetzung eines Gedichts, „Mir träumte von einem Königskind", von Heinrich Heine.
Original in Esperanto verfasste Lyrik und Übersetzungen ins und aus dem Esperanto stehen somit am Anfang der Sprache und bilden eine Kontinuität bis in die Gegenwart. Auf eine besondere Weise erzählt dies Clemens Setz in seinem Buch „Die Bienen und das Unsichtbare" (2020), das auch als persönliche Anthologie plansprachlicher Lyrik gelesen werden kann.

Dass Esperanto kein isoliertes Phänomen ist, wird durch mehr als 500 Plansprachen (projekte) belegt, die seit dem Mittelalter entstanden sind. Ein Großteil dieser Sprachen wird in der Sammlung für Plansprachen und im Esperantomuseum der Österreichischen Nationalbibliothek – der weltweit umfangreichsten Sammlung zum Thema Esperanto, Plansprachen und Interlinguistik – dokumentiert. (Bernhard Tuider)

1
Brief von Émilc Boirac an Wilhelm Ostwald, 18.01.1908. Zitiert nach: Gaston Waringhien (Hrsg.): *Leteroj de L.-L. Zamenhof II 1907-1914*. Paris 1948, S. 139. Übersetzung: „Für uns [Esperanto-Sprecher] ist Esperanto schon eine existierende Sprache, lebend, ähnlich in dieser Beziehung den natürlichen und nationalen Sprachen, Englisch, Französisch, Deutsch, usw. Es ist folglich wie sie ein Faktum und sogar ein soziales Faktum, das sich weiterentwickelt, so wie alle sozialen Fakten, [...]."

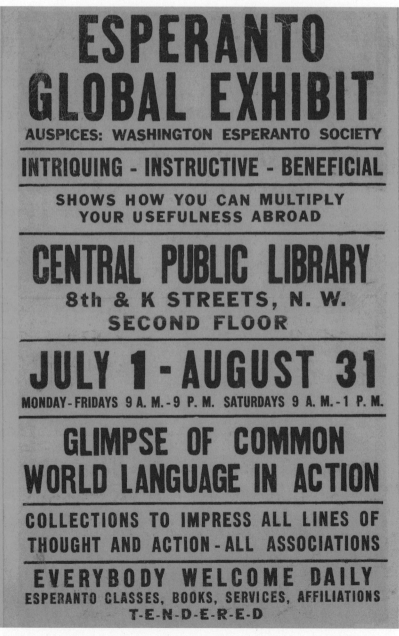

JOHANN GEORG HETTINGER
PFINGSTEN, 1712
Red chalk drawing, 50 × 70 cm
Courtesy: Diözesanmuseum Hofburg Brixen / Museo Diocesano di Bressanone

The Holy Spirit comes at Pentecost
New Testament, Acts 2, 1- 11:

1 When the day of Pentecost came, they were all together in one place. 2 Suddenly a sound like the blowing of a violent wind came from heaven and filled the whole house where they were sitting. 3 They saw what seemed to be tongues of fire that separated and came to rest on each of them. 4 All of them were filled with the Holy Spirit and began to speak in other tongues as the Spirit enabled them. 5 Now there were staying in Jerusalem God-fearing Jews from every nation under heaven. 6 When they heard this sound, a crowd came together in bewilderment, because each one heard their own language being spoken. 7 Utterly amazed, they asked: "Aren't all these who are speaking Galileans? 8 Then how is it that each of us hears them in our native language? 9 Parthians, Medes and Elamites; residents of Mesopotamia, Judea and Cappadocia, Pontus and Asia, 10 Phrygia and Pamphylia, Egypt and the parts of Libya near Cyrene; visitors from Rome 11 (both Jews and converts to Judaism); Cretans and Arabs – we hear them declaring the wonders of God in our own tongues!"

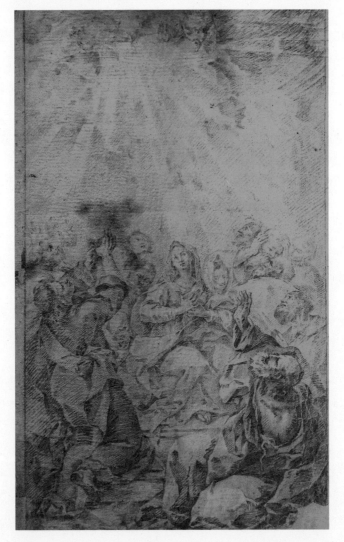

MIRELLA BENTIVOGLIO (*1922, Klagenfurt am Wörthersee, Austria, †2017, Roma, Italia)
LA PROFEZIA (DA BABELE A GROUND ZERO), 2001-2002
Stampa fotomeccanica su carta, 66,3 × 96,5 cm
Courtesy: Archivio Mirella Bentivoglio, Roma

Artista, poetessa, performer, critica, curatrice, Mirella Bentivoglio ha sempre posto al centro del suo lavoro la riflessione sulle diverse declinazioni assunte dal linguaggio.

In quest'opera appartenente alla sua ultima produzione propone un parallelismo tra la storia biblica della Torre di Babele – momento in cui Dio, per punire gli uomini, "confuse le lingue" e quindi assumibile a mito fondativo della traduzione – e le macerie di Ground Zero all'indomani degli attentati dell'11 settembre 2001. In particolare riprende una delle rappresentazioni di questo episodio biblico realizzata Pieter Bruegel il Vecchio la cosiddetta "Grande Torre" (1563) del Kunsthistorisches Museum di Vienna. Estrapolando dal quadro originale (di formato orizzontale) la sola presenza architettonica della torre e ritagliandola nel momento centrale del trittico – isolandola così ulteriormente dal contesto circostante – l'artista crea un rimando in primo luogo formale con gli scheletri delle due torri, aprendo al contempo una riflessione sul crollo di queste realtà, sui significati simbolici che veicolano, e sulle diaspore ad esse connesse "il Signore li disperse su tutta la terra". (Anna Zinelli)

The Tower of Babel
Old Testament, The Book of Genesis, Chapter 11, 1-9:

1 Now the whole world had one language and a common speech. 2 As people moved eastward, they found a plain in Shinar and settled there. 3 They said to each other, "Come, let's make bricks and bake them thoroughly." They used brick instead of stone, and tar for mortar. 4 Then they said, "Come, let us build ourselves a city, with a tower that reaches to the heavens, so that we may make a name for ourselves; otherwise we will be scattered over the face of the whole earth." 5 But the Lord came down to see the city and the tower the people were building. 6 The Lord said, "If as one people speaking the same language, they have begun to do this, then nothing they plan to do will be impossible for them. 7 Come, let us go down and confuse their language so they will not understand each other." 8 So the Lord scattered them from there over all the earth, and they stopped building the city. 9 That is why it was called Babel – because there the Lord confused the language of the whole world. From there the Lord scattered them over the face of the whole earth.

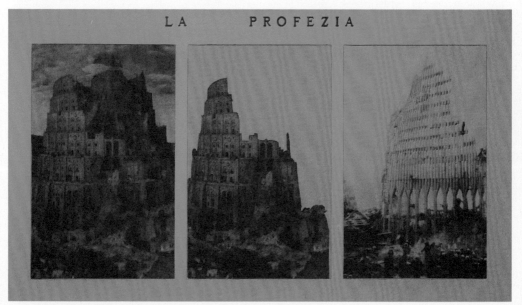

LA PROFEZIA

FREUNDESKREIS FEAT. DÉBORAH
(* Gegründet in 1996 in Stuttgart, Deutschland – Aufgelöst im Jahr 2007)
ESPERANTO, 1999
Musikvideo von Studio FILM BILDER, Stuttgart, 3'59"
Courtesy: the artists and Universal Music

"Esperanto, Standpunkt unsresgleichen
Von denen, die die und nicht nur sich an der Kultur bereichern
Ein Synonym für lasst hundert Blumen blüh'n
Hundert Schulen in Rapcyphers miteinander wetteifern
Esperanto: Antwort auf den kulturellen Bankrott
Musik ist Weltsprache, keine schnelle Geldmache
Escuchar el lenguaje, raps bel canto
Fiedel dem Biz wie Castro die erste Geige zu sei'm letzten Tango
Esperanto: eloquente, Definition:
Ein schnellerlernter Lingo zur Verständigung der Nation'
Basiert auf Romanisch, Deutsch, Jiddisch, Slawisch
Kein Sprachimperialismus oder Privileg des Bildungsadels
Esperanto, kein Manko, wenn ihr's nicht gleich versteht
Wichtiger ist, dass ihr zwischen den Zeilen lest
Euch unser Style beseelt, fühlt was mein Input ist
Ich sei Lyricist, internationaler Linguist
Miliano Soulguerillo
Der Texterpartisane, der letzte Mohikaner
Am Mikro, amigos, estaj representando
FK Amikaro, Motto Esperanto

Esperanto, c'est la langue de l'amour, (que)
Tout à tout vient à parler
Esperanto, et à ce jour l'espoir est née
Esperanto"

Auszug aus den Lyriks von FREUNDESKREIS FEAT. DÉBORAH, ESPERANTO, 1999
Courtesy: the artists and Universal Music

OTTO NEURATH (*1882, Wien, Österreich, †1945, Oxford, England) GESELLSCHAFT UND WIRTSCHAFT. BILDSTATISTISCHES ELEMENTARWERK. PRODUKTIONSFORMEN, GESELLSCHAFTSORDNUNGEN, KULTURSTUFEN, LEBENSHALTUNGEN, 1930 Bogen Nr. 56, Bogen Nr. 23, Kraftwagenbestand der Erde, 30,4 × 45,8 cm Courtesy: Österreichisches Gesellschaft- sund Wirtschaftsmuseum

Otto Neurath, Ökonom, Wissenschaftstheoretiker, Pädagoge und Grafiker aus Wien, setzte es sich zum Ziel, eine internationale Bildsprache zu entwickeln. Sein Wunsch war es, eine visuelle Ausdrucksform zu finden, die von allen Menschen – auch jenen die nicht lesen oder schreiben können – verstanden werden kann. Zugang zu Bildung für alle, jenseits nationaler Grenzen und sozialer Klassen, lautete seine Divise. In Oxford gründete Neurath 1940 ein Institut, dass sich ausschließlich der Entwicklung von „Isotype" widmete. „Isotype" steht für "International System of Typographic Picture Education" und stellt die Grundlage Neuraths bildpädagogischer Arbeiten dar. (Judith Waldmann)

THE TRANSLATION OF (VISUAL) POETRY

Le ricerche concrete e verbovisuali, attraverso l'indagine dei rapporti tra parola poetica e immagine, sono profondamente correlate sia con il processo della traduzione sia con la questione dell'intraducibilità.

Tra i primi protagonisti del concretismo[1] troviamo, ad esempio, il gruppo brasiliano Noigandres, costituitosi nel 1952 intorno all'omonima rivista su iniziativa di Haroldo de Campos, Augusto de Campos e Décio Pignatari. Tutti e tre, oltre che poeti e saggisti, sono traduttori e tutti e tre concepiscono queste attività come strettamente interrelate.

Tra le loro numerosissime traduzioni, spesso realizzate insieme, si possono ricordare quelle di Stéphane Mallarmé, James Joyce, Gertrude Stein, Vladimir Majakovskij, Ezra Pound, ma anche di Dante[2], di poeti provenzali o barocchi[3]: "gli intradotti e gli intraducibili", per citare le parole di Augusto de Campos.[4] Proprio a un termine intraducibile si lega anche la scelta del nome del gruppo Noigandres, ripreso dal XX Canto di Ezra Pound, che, a sua volta, si rifaceva a un enigmatico verso del trovatore occitano Arnaut Daniel.

In particolare, Augusto de Campos ha affermato: "Traduzione per me è persona. Quasi eteronimo. Entrare nella pelle del fingitore per ri-fingere tutto ancora, dolore con dolore, suono con suono, colore con colore."[5] Se per Fernando Pessoa, lo scrittore dagli oltre cento eteronimi, "il poeta è un fingitore"[6], l'artista – ironicamente quasi omonimo di Álvaro de Campos, uno dei più celebri alter ego dell'autore portoghese – legge la traduzione come una reiterazione di questo atto, un "ri-fingere" appunto. Al contempo traduzione come "persona", "quasi eteronimo" presuppone (quasi), la creazione di un nuovo autore fittizio dotato, nonostante la dimensione immaginaria, di una propria personalità.

Questa polarizzazione tra centralità della traduzione, intesa "poundianamente" come atto critico-interpretativo e come processo di creazione, e questione dell'intraducibilità, ad esempio di giochi di parole, di termini dal significato ignoto (come nel caso di Arnaud) o anche di vocaboli o simboli volutamente "desemantizzati", può quindi essere assunta come tratto distintivo che accompagna le sperimentazioni verbovisuali.

Nelle loro differenti declinazioni, esse hanno infatti promosso una costante ricerca di dialogo e scambio internazionale, che ha avuto un proprio canale privilegiato nella cosiddetta esoeditoria[7], cioè nella realizzazione di libri e riviste d'artista autoprodotti, esterni ai canali di produzione e distribuzione ufficiali, che agivano anche come piattaforme di scambio e incontro tra lingue e linguaggi artistici di differente provenienza (si pensi all'ampia presenza di collaboratori esteri in riviste italiane come "Antipiugiù" o "Lotta poetica"[8] o a casi esteuropei come la rivista "Signal", pubblicata a Belgrado in serbo e inglese, che raccoglieva contributi di artisti visivi provenienti da tutto il mondo).

Gli echi di tale polarità emergono anche nella scelta di opere verbovisuali proposte in mostra da Judith Waldmann. Oltre alla figura di Augusto de Campos, incontriamo un'altra artista proveniente dal contesto brasiliano, Lenora de Barros. Appartenente alla generazione successiva rispetto agli esponenti di Noigandres, negli anni '70 collabora proprio con i fratelli de Campos alla rivista sperimentale "Poesia em greve". Nel lavoro esposto a Merano, "Poema" (1980-1990), contamina, in una serie di fotografie in cui la sua lingua si appoggia a parti di una macchina da scrivere, la sperimentazione linguistica di matrice concreta con la body art. Nel 1991, de Barros cura inoltre, con Paula Mattoli, la mostra "Poesia Concreta in Brasile" presso l'Archivio della Grazia di Nuova Scrittura di Milano. In quell'occasione viene pubblicato un catalogo contenente le traduzioni italiane dei manifesti e dei testi teorici del gruppo[9], nonché una serie di lavori dei suoi esponenti accompagnati da "chiavi di lettura", cioè traduzioni delle parole usate nelle opere.

In "The Poetry of Translation" incontriamo anche un'altra importante esponente delle ricerche verbovisuali: Mirella Bentivoglio. Nata a Klagenfurt e cresciuta in Svizzera con un'educazione trilingue, negli anni '60 si accosta alla poesia concreta e, successivamente, visiva, coltivando in parallelo l'attività critica e curatoriale. In mostra sono presenti numerosi suoi lavori che spaziano dagli stranianti giochi di parole degli anni '70 (come lo slittamento semantico determinato dall'aggiunta della piccola "a" accanto al "noi" in "Noia", del 1975) a opere più tarde come "La Profezia" (2001-2002), che crea un parallelismo tra la storia biblica della Torre di Babele – momento in cui Dio, per punire gli uomini, "confuse le lingue" e quindi assumibile a mito fondativo della traduzione – e gli attentanti nell'11 settembre 2001. Inoltre, la scelta di Judith Waldmann di esporre i lavori di una serie di artiste legate alla poesia visiva rende omaggio anche al ruolo curatoriale di Bentivoglio e in particolare alla mostra "La materializzazione del linguaggio"[10], che aveva curato nel 1978 in occasione della XXXVIII Biennale di Venezia. Indagando il rapporto tra artiste e linguaggio[11] la mostra ai Magazzini del Sale andava a compensare la carenza di presenze femminili in laguna (e, più genericamente, nei contesti espositivi ufficiali), ma anche a tracciare una ricognizione storica che spaziava dalle avanguardie russe (ad esempio, con Natalia Gončarova) alle coeve ricerche internazionali, ancora una volta all'insegna dello scambio, del dialogo, dell'incontro a partire dall'aspetto linguistico, nelle sue differenti declinazioni, nonostante e attraverso le differenze.

A Merano ritroviamo, seppur con opere diverse, una serie di artiste che erano state esposte in tale occasione[12]. Se si guarda alle strategie messe in atto da queste sperimentazioni – ad esempio il collage su spartito "Andante – Adagio"

(1982) di Anna Esposito o il video "Appendice per una supplica" (1972) di Ketty La Rocca – emerge come esse siano connotate dal binomio "traduzione"/"intraducibilità" anche in relazione alla trasposizione da un sistema di segni a un altro, quali il verbale e il grafico-pittorico ma anche la dimensione sonora e gestuale. (Anna Zinelli)

1

Cfr. Andreas Hapkemeyer, "Poesia Concreta" in: *La parola nell'arte*, MART, Skira, Milano 2007, pp. 235-237.

2

Sulla traduzione del Paradiso di Haroldo de Campos si rimanda alle riflessioni di Umberto Eco in *Dire quasi la stessa cosa. Esperienze di traduzione*, Bompiani, Milano 2003, pp. 343-344.

3

Katia de Abreu Chulata, *Augusto de Campos fagocita Arnaut Daniel ed Ezra Pound per il bene della traduzione come ricreazione*, in Gloria Politi (a cura di), *Testo interartistico e processi di comunicazione. Letteratura, arte, traduzione, comprensione*, Pensa multimedia, Lecce 2014, pp. 1-12.

4

Augusto de Campos, *Verso, reverso, controverso*, Perspectiva, São Paulo 2009, p.7, in: Katia De Abreu Chulata, op. cit., p. 4.

5

Ivi, p. 2.

6

Fernando Pessoa, *Il poeta è un fingitore. Duecento citazioni scelte da Antonio Tabucchi*, Feltrinelli, Milano 1988.

7

Cfr. Giorgio Maffei, Patrizio Peterlini, *Riviste d'arte d'avanguardia: esoeditoria negli anni Sessanta e Settanta in Italia*, Bonnard, Milano 2005.

8

In particolare "Lotta poetica", nata dall'unificazione di "Tafelronde" di Anversa e "Amodulo" di Brescia, si pone programmaticamente lo scopo di coniugare la componente internazionalista con quella dell'impegno politico, avvalendosi di collaboratori provenienti dalla Francia, dalle due Germanie, dalla Jugoslavia, dalla Cecoslovacchia.

9

Lenora de Barros, Paula Mattoli, *Poesia concreta in Brasile*, Archivio della grazia di nuova scrittura, Milano 1991.

10

Mirella Bentivoglio (a cura di), *Materializzazione del linguaggio*, catalogo della mostra, Magazzini del Sale alle Zattere, Venezia 20 settembre-15 ottobre 1978.

11

In catalogo, Bentivoglio riconduce il concetto di "materializzazione" al termine *mater*, madre, in contrapposizione ai codici univoci di cui è portatore un linguaggio patriarcale.

12

In mostra incontriamo, oltre a Mirella Bentivoglio, Irma Blank, Tomaso Binga, Anna Esposito, Elisabetta Gut, Lucia Marcucci, Amelia Etlinger – tutte esposte in occasione della mostra veneziana, anche se non con gli stessi lavori – e Carla Accardi.

"The Poetry of Translation",
installation view: Elisabetta Gut,
Marilla Battilana, Mirella Bentivoglio,
Tomaso Binga.
Kunst Meran Merano Arte 2021

"The Poetry of Translation",
installation view: Ketty La Rocca,
Marilla Battilana,
Mirella Bentivoglio, Elisabetta Gut.
Kunst Meran Merano Arte 2021

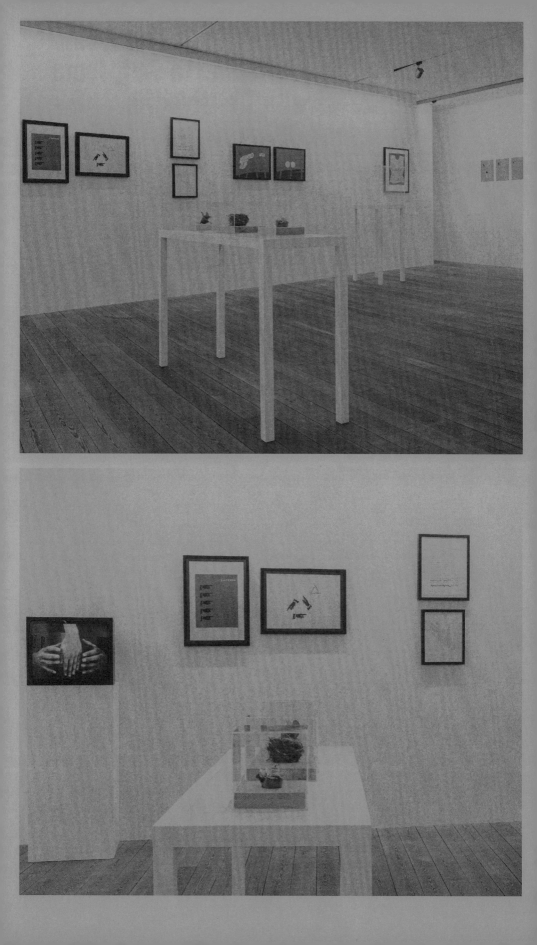

"The Poetry of Translation",
installation view: Elisabetta Gut, Irma
Blank, Mirella Bentivoglio.
Kunst Meran Merano Arte 2021

"The Poetry of Translation",
installation view: Mirella Bentivoglio.
Kunst Meran Merano Arte 2021

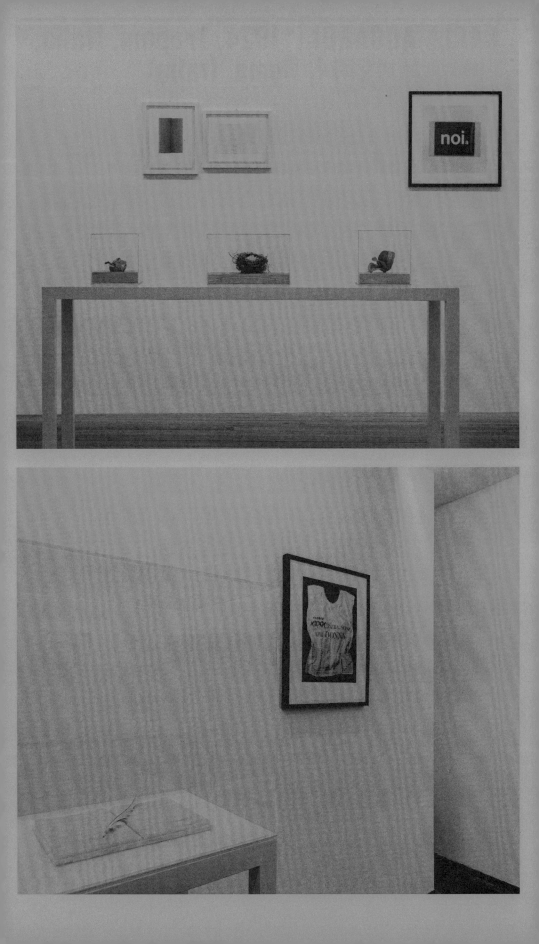

CARLA ACCARDI (*1924, Trapani, Italia, †2014, Roma, Italia)

LABIRINTO, 1957
Tempera alla caseina su tela, 60 × 90 cm
Courtesy: the artist, Stiftung MUSEION.
Museum für moderne und zeitgenössische
Kunst Bozen – Sammlung Autonome Provinz
Bozen – Südtirol / Fondazione MUSEION.
Museo d'arte moderna e contemporanea
Bolzano – Collezione Provincia
Autonoma di Bolzano – Alto Adige
Foto: Antonio Maniscalco

BELVEDERE 373, 1963
Tempera alla caseina su tela,
100 × 133 × 2,6 cm
Courtesy: the artist, Stiftung MUSEION.
Museum für moderne und zeitgenössische
Kunst Bozen – Sammlung Autonome
Provinz Bozen – Südtirol / Fondazione
MUSEION. Museo d'arte moderna e
contemporanea Bolzano – Collezione Provincia
Autonoma di Bolzano – Alto Adige
Foto: Antonio Maniscalco

Tra le figure di punta dell'astrattismo dal secondo dopoguerra, nella sua decennale attività Carla Accardi ha sviluppato una propria cifra stilistica riconoscibile, incentrata sul linguaggio segnico, pur con differenti variazioni. Dai primi anni '60 l'artista è passata da una produzione improntata sulla bicromia (bianco e nero) al recupero del colore, come nel caso di "Belvedere 373" (1963), in cui sovrappone a uno sfondo azzurro una serie di segni-simbolo di colore verde, che sembrano rimandare a calligrafie arabe o estremorientali. (Anna Zinelli)

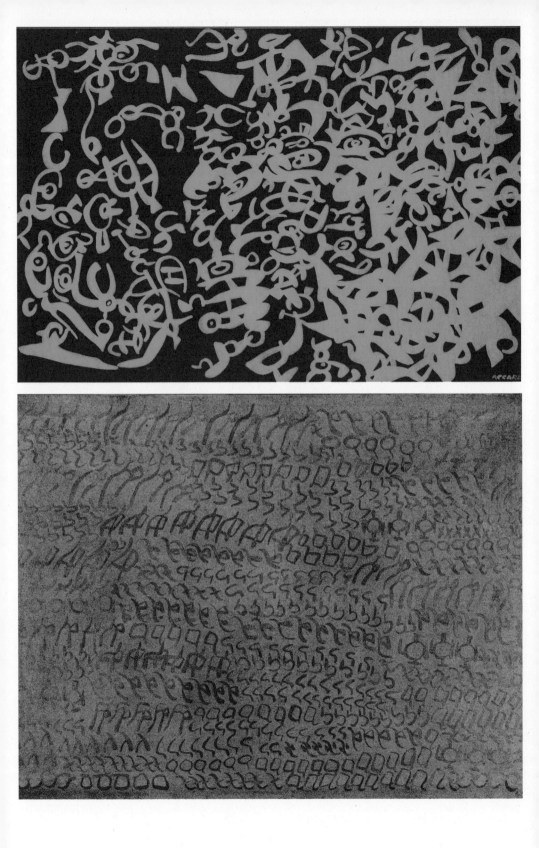

**IRMA BLANK (*1934, Celle, Germania)
EXERCITIUM NR. 4, RADICAL WRITINGS, 1989**
Olio su carta, 29 × 31 × 2 cm
Courtesy: the artist, Stiftung MUSEION.
Museum für moderne und zeitgenössische
Kunst Bozen - Sammlung Archivio
di Nuova Scrittura / Fondazione MUSEION.
Museo d'arte moderna
e contemporanea Bolzano - Collezione
Archivio di Nuova Scrittura
Foto: Gardaphoto s.r.l., Salò

**SCHRIFT-ATEM-ÜBUNG 2,
RADICAL WRITINGS, 1989**
Acrilico su carta, 31 × 39 × 2 cm
Courtesy: the artist, Stiftung MUSEION.
Museum für moderne und zeitgenössische
Kunst Bozen - Sammlung Archivio
di Nuova Scrittura / Fondazione MUSEION.
Museo d'arte moderna
e contemporanea Bolzano - Collezione
Archivio di Nuova Scrittura
Foto: Gardaphoto s.r.l., Salò

Con la serie "Radical Writings", a cui si è dedicata dai primi anni '80 ai primi anni '90, Irma Blank continua un'indagine sulla scrittura riducendola a puro segno astratto, traducendola in linee di colore, eliminando il significato di parole, sintassi, impaginato e evocandolo al contempo. L'azione dello scrivere non veicola nulla di codificato ma unicamente un non detto, uno spazio interstiziale tra linguaggio e processo meditativo. (Anna Zinelli)

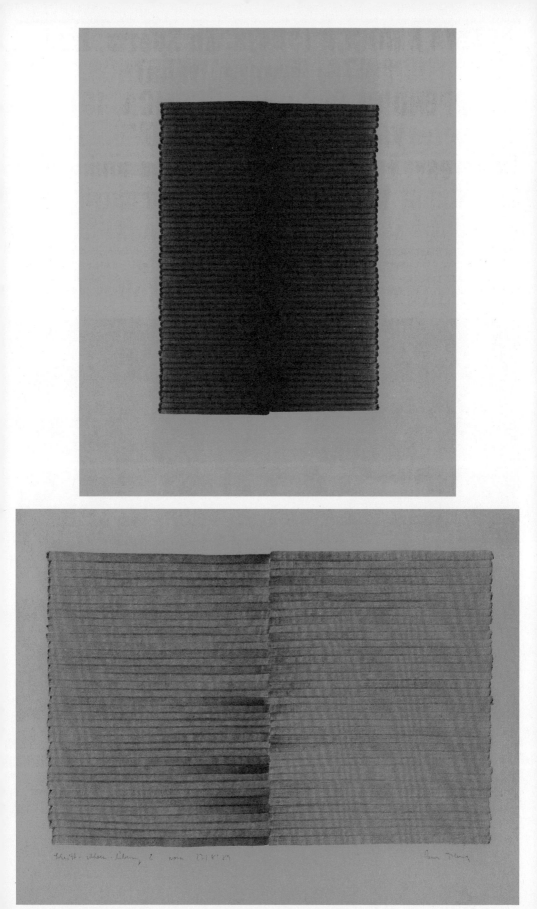

KETTY LA ROCCA (*1938, La Spezia, Italia, †1976, Firenze, Italia)
APPENDICE PER UNA SUPPLICA, 1972
Video, muto, b/n, 9'30"
Courtesy: Estate Ketty La Rocca and Kadel Willborn, Düsseldorf

Presentato alla Biennale di Venezia del 1972, "Appendice per una supplica" è un video con cui Ketty La Rocca porta avanti una ricerca sul linguaggio espressivo del gesto, in particolare delle mani, in una dimensione estranea a quella dei codici della comunicazione. Le mani dell'artista si incontrano con quelle di un attore, traducendo questo dialogo in un alfabeto gestuale inedito, lontano da qualunque significato prestabilito. (Anna Zinelli)

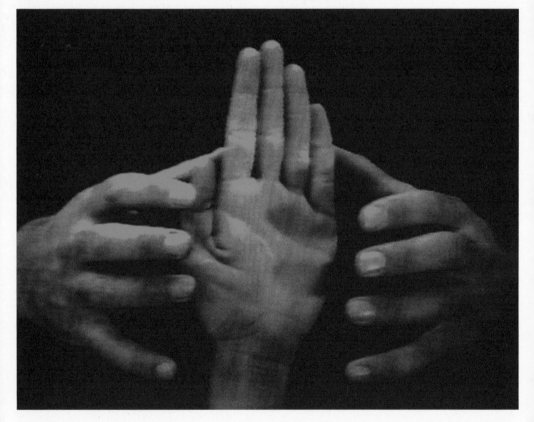

TOMASO BINGA (*1931, Salerno, Italia)
ALFABETO VOCALICO, 1975
Scrittura desemantizzata
e collage su carta, 21 schede, 42 × 30 cm
Courtesy: the artist

A partire dai primissimi anni '70 l'artista Bianca Pucciarelli ha assunto lo pseudonimo maschile Tomaso Binga al fine di mettere in luce, in modo ironico e spiazzante, i privilegi maschili che sussistono nel mondo dell'arte. In questi stessi anni ha avviato una ricerca sul significato dei segni alfabetici e sulla loro possibile traduzione in una "scrittura vivente" e "desemantizzata", in cui rientra anche il lavoro "Alfabeto vocalico" (1975): 21 collage dedicati alle 21 lettere dell'alfabeto italiano, in cui il corpo dell'artista si inserisce in corrispondenza delle vocali. (Anna Zinelli)

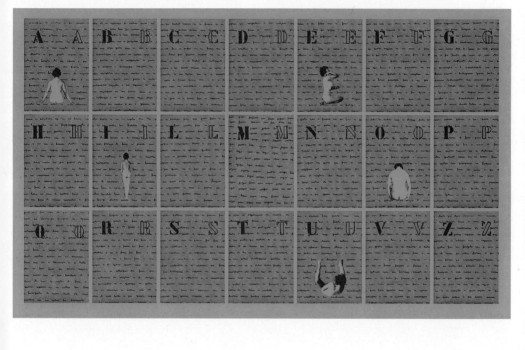

HEINZ GAPPMAYR (*1925, †2010, Innsbruck, Österreich)
BLAU HELLBLAU WEISS BLU BLU CHIARO BIANCO, 1999
Courtesy: the artists and Krankenhaus Meran, Südtirol. Mit freundlicher Genehmigung von Dr.In Irene Pechlaner, Direktorin des Gesundheitsbezirkes Meran

Ende der 1950er Jahre stößt Heinz Gappmayr zur Bewegung der visuellen Dichter. Diese versuchten damals von Europa und Südamerika aus, die internationale Dichtung grundlegend zu erneuern. Visuelle Texte verzichten auf die Syntax, dafür beziehen sie die Fläche (das Blatt) ein, auf dem die Wörter oder Buchstaben sich verteilen. Visuelle Texte sind Hybride zwischen Text und Bild. Gappmayrs Arbeit für das Krankenhaus Meran ist eine einfache Textzeile, die in deutscher und italienischer Sprache von einer Farbabstufung spricht: von blau über hellblau zu weiss. Der auf einer weißen Wand (im Eingangsbereich) installierte Text vollzieht als ganzer die Farbabstufung graduell von links nach rechts. Die deutschen Wörter gehen farblich von blau zu hellblau über, während der italienische Text von hellblau bis weiss reicht. Es handelt sich zum einen um einen Prozess der Verschwindens. Die einzelnen Farbwörter stimmen aber auch nicht genau mit der Farbe überein, in der sie gemalt sind. Das Auseinanderfallen zwischen Farbwörtern und der Farbe, in der sie geschrieben sind, macht deutlich, dass Sprache unabhängig von der Farbe ihrer Lettern die Vorstellung ganz anderer Farben hervorrufen kann. Jede Sprache hat dabei eine andere Konvention, wie sie etwas – z.B. eine Farbe – nennt: blau, bleu, blue, blu/celeste... Gappmayrs Text thematisiert auch, dass dasselbe Farbwort zur Bezeichnung einer Vielfalt von Tonalitäten verwendet wird, von denen eine RAL-Tabelle einen guten Eindruck gibt. Das für das Farbadjektiv blau von Gappmayr verwendete Blau ist nur eine Manifestation ganz verschiedener Möglichkeiten. Gappmayr spricht schließlich die Schwierigkeit der genauen Abgrenzung an: Wo endet blau und wo beginnt hellblau? Je genauer man hinschaut, desto komplexer wird es. Visuelle Poesie heißt nicht zufällig auch linguistische Poesie.
(Andreas Hapkemeyer)

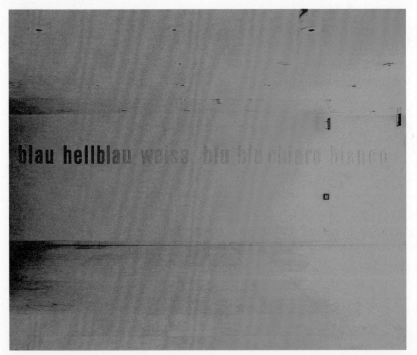

LAWRENCE WEINER (*1942, †2021, New York, United States)
DRAUSSEN AM UFER DES OZEANS - DRAUSSEN AM FUSS DES BERGES / FUORI SULLA RIVA DELL'OCEANO - FUORI DELLA MONTAGNA, 1999
Courtesy: the artists and Krankenhaus Meran, Südtirol. Mit freundlicher Genehmigung von Dr.In Irene Pechlaner, Direktorin des Gesundheitsbezirkes Meran

Lawrence Weiner ist – zusammen mit Robert Barry und Joseph Kosuth – einer der Künstler, die Mitte der 1960er Jahre Bild und Objekt durch Texte ersetzen. Ausgangspunkt ist dabei ein vom Künstler auf Papier festgehaltenes Konzept. Da dieses Konzept das Original ist, ist ein auf der Wand ausgeführtes Werk lediglich eine mögliche Manifestation, die nach Ende der Ausstellung einfach übermalt werden kann. Mit Weiner, Kosuth und Barry gelangt die auf permanente Erneuerung ausgerichtete Moderne zur Entmaterialisierung des Kunstwerks.

Der Einsatz von Sprache in einem Werk erwartet von den Betrachtenden, dass sie die Sprache verstehen. Weiner geht vom Englischen aus; an den Orten, an denen er ausstellt, werden seine Texte immer in die Ortsprache(n) übersetzt. Nach Weiners eigener Definition bestehen seine Werke aus Wörtern und den Materialien, die diese Wörter evozieren. Im konkreten Fall ist von Materialien die Rede, die wir mit Natur identifizieren: von Wasser (OZEAN) und Land (UFER), von sich auftürmendem Stein (BERG) und dem Übergang zur Ebene (FUSS DES BERGES). Wohlgemerkt: die von Weiner verwendeten Wörter sollen die Vorstellung von Materialien in unserer Vorstellung wachrufen, diese Materialien sind aber physisch nicht da.

Das auf dem Krankenhaus Meran angebrachte Werk war 1992 Teil der Ausstellung „Denkräume" im Museion, die außer Weiner auch Heinz Gappmayr und Maurizio Nannucci zeigte. „OUT ON THE OCEAN SHORE / OUT ON THE BOTTOM OF THE MOUNTAIN" (1999) ist Teil einer dreisprachigen Trilogie, deren andere zwei Teile in der Sammlung des Museion verwahrt werden. Diese drei Texte sind in das 1992 vom Museion produzierte, dreisprachige Künstlerbuch Weiners „ALL FALL DOWN" eingegangen, in dem sie ein verborgenes, aber einer Wandinstallation gleichwertiges Dasein führen.
(Andreas Hapkemeyer)

MARIA STOCKNER (*1964, Brixen, Italy)
GRACE, 2019
Glass object with egg, wood,
10 × 17cm
Courtesy: the artist

Gracefulness is an idea not very different from beauty; it consists of much the same things. Gracefulness is an idea belonging to posture and motion. In both these, to be graceful, it is requisite that there be no appearance of difficulty; there is required a small inflection of the body; and a composure of the parts in such a manner, as not to encumber each other, not to appear divided by sharp and sudden angles. In this ease, this roundness, this delicacy of attitude and motion, it is that all the magic of grace consists, and what is called its "je ne sçai quoi"; as will be obvious to any observer, who considers attentively the Venus de Medicis, the Antinous, or any statue generally allowed to be graceful in a high degree. (Edmund Burke, *On the Sublime and Beautiful*, 1757.)

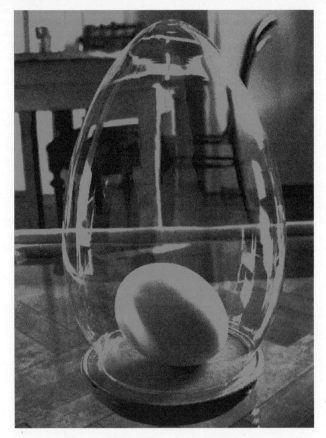

...WENN NUR MEINE BÖSEN TRÄUME NICHT WÄREN, 2021
Walnut, Wood sculpture, 30 × 30 cm
Courtesy: the artist

I could be bounded in a nutshell, and count myself a king of infinite space,
were it not that I have bad dreams.
(William Shakespeare, *Hamlet*, 1600-1602.)

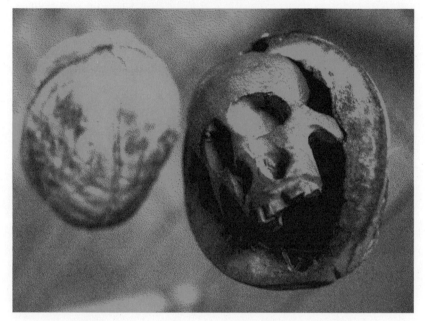

ANRI SALA (*1974, Tirana, Albania)
ANSWER ME, 2008
HD Video, color, stereo, 4'50"
Courtesy: the artist
and Esther Schipper, Berlin

The video "Answer me" (2008) is about interpersonal communication. Filmed in the "Teufelsberg", a dilapidated US air surveillance and listening station in Berlin, a woman tries to end her relationship with her boyfriend. He answers her repeated requests to "answer me" with energetic drumbeats. The couple's dialogue is translated into two different sign systems – language and music. In his work, Anri Sala (who expressed his mistrust about language in an interview[1]) examines the potential of music as an alternative form of communication. (Judith Waldmann)

1
Anri Sala: Music Before Language. Interview with Jakob Solbakken and Marc-Christoph Wagner. Louisiana Channel, 2012. https://channel.louisiana.dk/video/anri-sala-music-language (Last retrieval on 22.11.2021)

CERITH WYN EVANS (*1958, Lianelli, Wales) GOODNIGHT EILEEN FROM HERE TO GO BY TERRY WILSON / BRION GYSIN (1982), 2003

Chandelier (Varovier & Toso), flat screen, morse machine, computer, dimensions variable
Courtesy: the artist and Stiftung MUSEION. Museum für moderne und zeitgenössische Kunst Bozen - Sammlung Autonome Provinz Bozen - Südtirol / Fondazione MUSEION. Museo d'arte moderna e contemporanea Bolzano - Collezione Provincia Autonoma di Bolzano - Alto Adige

Characteristic of Cerith Wyn Evans' work, "Goodnight Eileen" (2003) from "Here to Go" by Terry Wilson / Brion Gysin (1982), is an eccentric dalliance with the supernatural. Wyn Evans mobilizes a complex of translations: between languages, between language and sculpture. The combined effect is a phenomenology, that teases the threshold of magic.

"Goodnight Eileen" begins with a textual appropriation. The words come from an interview between Terry Wilson and the artist Brion Gysin, famous progenitor of the "cut-up" writing technique, inventor of the Dream Machine, a kinetic and illuminated device for engendering closed-eye hallucinations, and friend of William Burroughs, who said: "Brion Gysin was the only man I ever respected."

The interview concerns Eileen Garrett, a spiritual medium who enjoyed publicity in the 1920s and 1930s, before receding into obscurity, and rumours of CIA collaboration. On a video screen, the interview can be seen translating into Morse code. In turn, the code is transmitted to the blinking lights of a hanging chandelier. The twinkling chandelier evokes a seance-incanted ghost, attempting to contact the living. Meanwhile, Wyn Evans channels the entangled spirits of his creative predecessors. The work's uncanniness amplifies that of translation itself: both language and the perception of reality that it affords, are transmuted through the translator's work. By way of this omnipresent and eery human phenomenon, Wyn Evans draws his viewers into the irreducible locus of a singular experience, bizarre and charming. An analytical approach to language here collapses into reverence, for language's evasion of analysis itself. (Mitch Speed)

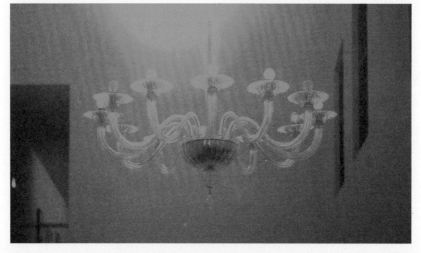

ALESSANDRO BOSETTI (*1973, Mailand, Italien)
PLANE/TALEA, 2016-ongoing
Polyphone Kompositionen
Courtesy: the artist

Alessandro Bosetti, Künstler, Komponist und Musiker, schafft es in seinen Kompositionen die Brücke zwischen intensivem Sounderleben und relevanten zeitgenössischen Thematiken zu schlagen. Das Konzert „Plane/Talea" baut auf dem Klangarchiv auf, für welches Bosetti bis dato tausende von Stimmen aufgezeichnet und archiviert hat. Diese Stimmen stammen von Individuen verschiedenster Herkunft, die dementsprechend verschiedenste Muttersprachen sprechen. Abstrahiert auf den Ton werden die Stimmen in eine universell verständliche Form gebracht: Sie werden zu Musik, zu einem Teil eines mehrstimmigen Konzertes. Im Kontext der Ausstellung „The Poetry of Translation", die sich mit Übersetzung und Mehrsprachigkeit auseinandersetzt leistet „Plane/Talea" einen wichtigen Beitrag: Ein Konzert der Mehrstimmigkeit, der Inklusion und der Gemeinschaft. (Judith Waldmann)

HEIDUNDGRIESS (ALEXANDRA GRIESS [*1977, Hameln, Germany] & JOREL HEID [*1977, Hameln, Germany])
UNTITLED, 2013
32 programmed and dimmable fluorescent tubes, 7,1 × 4,85 × 2,8 m
Courtesy: the artists

"Untitled" (2013) is an installative translation of a 5-minute choreography
by Veronique Langlott, which deals with the discrepancy between the concepts of "to believe"
and "to know". (Alexandra Griess, Jorel Heid)

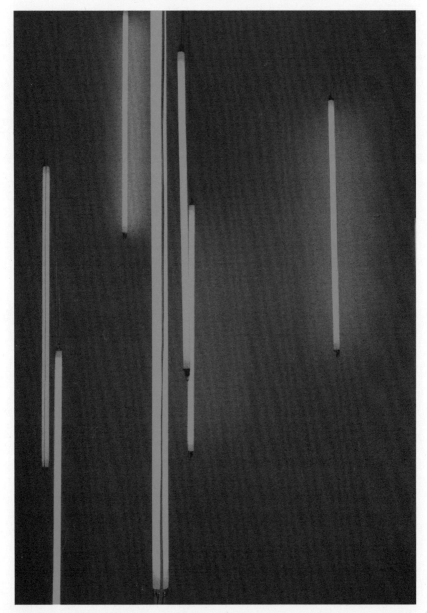

JORINDE VOIGT (*Frankfurt am Main, Germany)
LUDWIG VAN BEETHOVEN / SONATE, 2012
Ink, pencil on paper, 86,5 × 140 cm
Courtesy: the artist

"In her art, Jorinde Voigt has developed a coded form of writing in her drawings to transform the phenomena of our world into visual compositions. No matter how complex the processes may be, they arrive at a state of order through the systems employed by the artist. Through poetic webs of lines, mathematical grids, and musical patterns Voigt examines the processes of our perception in her drawings.

In the thirty-two-part cycle, the artist for instance takes an exemplary approach to translating Beethoven's music into her own personal language of symbols, with an aim to highlight its universal state. Music illustrates how, in our everyday world of experience, emotions develop into structures. This is in turn expressed in musical compositions through changes in melody and rhythm, as well as tempo and volume. The latter is notated with performance instructions like "piano" (quietly) or "forte" (loudly). Moreover, expressive direction like "cantabile" (in a singing manner) or "maestoso" (majestically) instruct musicians to give voice to a certain emotional state through their playing. In this series of drawings, the artist works with thirty-two piano sonatas composed by Beethoven between 1795 and 1822. Voigt uses one sheet for each sonata, which is traditionally comprised of two to four sections of the movement. The artist listens to the sonata while simultaneously making notations of the various strains – contingent on the interrelationship between the movements – in the space of the drawing. She labels them with

the related expressive directions after having translated them into English. The spectrum of musical expression thus becomes decipherable: "majestically, in a stately fashion", "cheerful or brisk, lively, fast with spirit/vigor, and passionately", or "at ease very simple and in a singing style". It is along these "trails" that Voigt chronologically lists, measure for measure, all further performance instructions for the entire sonata. Moreover, according to the number of movements, the artist drafts eyecatching axes across the paper, which she connects with the "trails" through sweeping lines. Voigt describes routes that can be taken to enable sounds, words, or sentiments to find expression. What is more, she situates the extractions from Beethoven's sonatas within her recurring notational system made of spatial and temporal parameters, such as "interne Zentren" (internal centers) and "externe Zentren" (external centers), "Rotationsrichtungen" (rotational directions), "Rotationsgeschwindigkeiten" (rotational speeds), "Nord-Süd-Achsen" (north-south axes), or "Beats" and "Loops."At the heart of her exhibition cycle is the transformative character inherent to notation. By example of Beethoven's sonatas, the artist translates music into the medium of drawing. Moving beyond a linear approach to listening to sounds, Voigt offers a visual experience that allows us to embrace the essentials of the composition with one glance".
(Reprint: Langen Foundation, *Jorinde Voigt – Ludwig van Beethoven Sonatas 1-32*, 2014.)

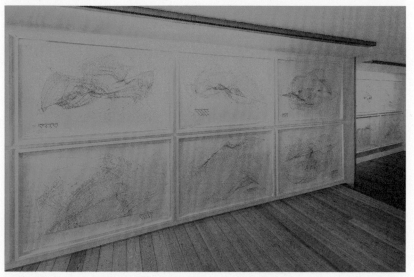

LEANDER SCHWAZER (*1982, Sterzing, Italien)
DAS KAPITAL, 2010
Metall, Papier, Variable Maße
Courtesy: the artist, Stiftung MUSEION.
Museum für moderne und zeitgenössische Kunst Bozen Fondazione MUSEION.
Museo d'arte moderna e contemporanea Bolzano

Die Klangskulptur „Der Arbeitstag" ist Teil einer Installation mit dem übergeordneten Titel „Das Kapital" (2011). Der Künstler Leander Schwazer bezieht sich damit auf das achte Kapitel aus dem ersten Band des Jahrhunderttextes von Karl Marx „Das Kapital. Kritik der politischen Ökonomie" (1867). Dort analysiert Marx, wie der Kapitalist „das Recht erlangt" hat, „den Arbeiter während eines Tags für sich arbeiten zu lassen" und erläutert dessen ausbeuterisches Prinzip des Warentauschs. Leander Schwazer überträgt den Marxschen Text auf das Endlospapier eines gelben Lochstreifenkartons. Er erscheint sowohl fortlaufend als Schrift am oberen Rand als auch darunter als Code durch eingestanzte Löcher. Dieser Transformation folgt aber keine Rückübersetzung in Schrift, sondern die Buchstaben werden in Töne übersetzt. Um sie zu hören, können die Betrachter:innen Hand anlegen und die Lochstreifen

mechanisch durch das Kurbelwerk einer Spieluhr ziehen – die Leier des Arbeitstages und seine augenzwinkernde Subversion.

Gleichsam spielerisch nimmt die Arbeit auch Bezug auf den Ingenieur Herman Hollerith. Als Erfinder der Lochkartenmaschine leitete er im Vorgriff auf die digitale Revolution den Beginn des Informationszeitalters ein. Während die Lochkarten zur Zeit von Marx für die Steuerung von Webstühlen eingesetzt wurde – ein Kern seiner Kapitalismuskritik – verwendete Hollerith sie als Datenspeicher, welcher dann als Computer so grundlegend unsere Arbeitswelt verändern sollte. Das Relikt aus den Anfängen der Datenverarbeitung und die Rückübersetzung des codierten „Kapitals" durch die alte Mechanik der Spielorgel verwandeln die 13000 Lochkarten in der Arbeit von Schwazer auf eine ebenso poetische wie subversive Weise in eine handbetriebene Klangskluptur. (Jenni Henke)

KINKALERI (Founded in 1995)
FOUND DANCE /ALL!, 2015/2021
Paper, 42 × 59,4 cm
Courtesy: the artists

Kinkaleri negli ultimi anni ha sviluppato un progetto sul linguaggio dal titolo "All!" strutturando percorsi fisici, verbali, visivi, sonori, mirati allo sviluppo di un pensiero nella totale libertà espressiva. Alla base di questa ricerca c'è l'invenzione del codiceK, un alfabeto gestuale che permette di trascrivere in continua dinamica nello spazio e nel tempo; una pratica coreografica dove una griglia rigida di traduzione tra alfabeto e gesto spalanca un luogo di libertà individuale sviluppando tutte le funzioni di un corpo compreso in un movimento. Una pura invenzione per far assumere a qualsiasi performer la scrittura come dato compositivo da interpretare qui e ora, adottando un codice/linguaggio che nella sua applicazione calligrafica ha la possibilità di divenire altro, travalicando la parola stessa e ridefinendo l'idea di coreografia. "Everyone Gets Lighter" è una performance sulla trasmissione dell'alfabeto gestuale che dall'atto divulgativo diviene danza; in un dispositivo saranno presentati da un performer tutti gli elementi costitutivi del codice, fornendo al pubblico le possibili applicazioni che coinvolgono il corpo nella sua potenzialità comunicativa e coreografica. La performance si propone di essere allo stesso tempo soggetto di pratica e di contemplazione. (Kinkaleri)

ETTORE FAVINI (*1974, Cremona, Italia)
MARE DAI MOLTI NOMI, 2020
Ricamo su jeans, sostegni in metallo verniciato, 250 × 170 × 25 cm
Collezione privata
Courtesy: Galleria Niccoli, Parma

"Mare dai molti nomi" è parte di un progetto più ampio, "Au revoir", articolato in differenti momenti espositivi ed editoriali, attraverso cui Ettore Favini indaga da diversi anni le rappresentazioni, le interpretazioni, le narrazioni del Mediterraneo e una delle più antiche tradizioni legate ad esso, quella della tessitura.

I "molti nomi" a cui allude il titolo – rifacendosi alle pagine del "Breviario mediterraneo" di Predrag Matvejević – sono quelli attribuiti dai diversi popoli che si affacciavano o che si affacciano su di esso (ad esempio il "Mare nostrum" per i romani o l'"al-Baḥr al-Abya al-Mutawassiṭ", ossia Mar Bianco di Mezzo, per gli arabi), ma sono anche le molte forme attraverso cui è stato "tradotto" e interpretato cartograficamente. Favini sovrappone infatti 16 mappe nella medesima scala, ognuna delle quali costituisce una differente "descrizione parziale o falsata del mondo", spaziando dalla Grecia antica a una mappa satellitare di Google. Ribaltando il punto di vista consueto, il bacino del Mediterraneo è restituito con un ricamo bianco che "galleggia" sul blu della stoffa jeans, rendendo irriconoscibili i suoi confini. (Anna Zinelli)

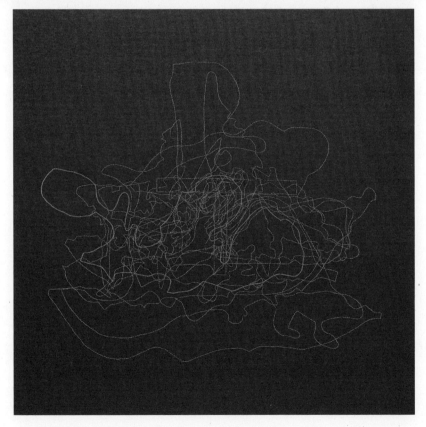

KADER ATTIA (*1970, Dugny, France)
MIMESIS AS RESISTANCE, 2013
Video, color, sound, 2'18"
Courtesy: the artist and Lehmann Maupin, New York
Julia Stoschek Foundation, Berlin / Düsseldorf

The Australian lyrebird has evolved the ability to perfectly mimic different sounds like no other bird. During the mating season, the lyrebird sings a mixture of its own tunes and those of other birds for hours on end. With the encroachment of humans upon its habitat, the birds have been exposed to new sounds, and they have been known to incorporate into their songs noises such as car alarms, camera shutters and even the sound of a chainsaw starting up. It is therefore the only animal that tragically incorporates the sounds of its own environment's gradual extinction. (Reprint: *Kader Attia – REPARATUR. 5 AKTE*, KW Institute for Contemporary Art, Berlin 2013.)

ANNIKA KAHRS (*1984, Achim, Germania)
PLAYING TO THE BIRDS (Filmstill), 2013
Video HD, colore, suono, 14'
Courtesy: the artist
and Produzentengalerie, Hamburg

Ci sono casi in cui la capacità di comprensione si avventura al di là dei limiti imposti dai linguaggi umani per sconfinare nel dialogo prodigioso con altre specie. Secondo la leggenda, San Francesco d'Assisi sarebbe stato in grado di parlare con gli uccelli, i quali l'avrebbero miracolosamente capito. Proprio sull'episodio della cosiddetta "Predica agli uccelli", autentico miracolo di traduzione, Annika Kahrs ha costruito l'opera "Playing to the Birds" (2013), basata sul concatenamento di tre diverse trasformazioni linguistiche.

La scena è la seguente: un elegante pianista esegue la composizione di Franz Liszt ispirata a San Francesco, detta "Leggenda n.1", in una sala da concerto. Nel suo susseguirsi di trilli acuti e squillanti, il brano ricorda i versi degli uccelli e viene suonato non di fronte a un pubblico di persone, quanto piuttosto per allietare una schiera di volatili. Ecco dunque la leggenda che si fa arte, i richiami animali che si trasformano in note, e infine il rovesciamento più importante: nell'opera della Kahrs il pezzo di Liszt torna a rivolgersi ai suoi destinatari originari, gli uccelli, permettendogli di ascoltare l'interpretazione umana del loro linguaggio.
(Federica Bertagnolli)

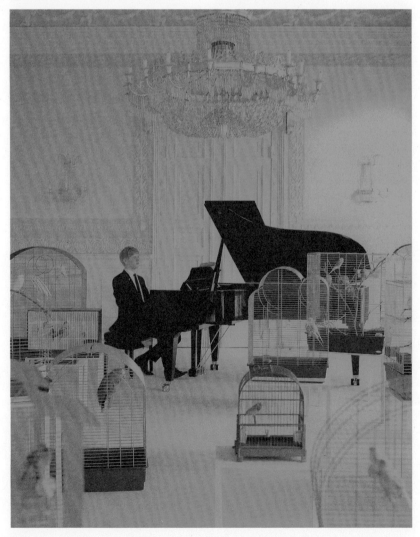

VITRINE BEFORE VITRINE AFTER

Dear visitor,
With what do you associate translation? Is there a personal object that evokes in you ideas, thoughts or associations about this phenomenon? If so, we would be delighted to learn more about this object and take it on loan for the duration of the exhibition.

This display case is in fact reserved for yourself and for all those wanting to participate in the exhibition and play a part in illustrating the diversity of translation.

The display case will grow over the course of the exhibition – or it might even be completely refilled. Discussion evenings will be held that you, dear visitor, will "lead" with your choice of object, sharing your knowledge or stories with everyone else. How will it work? Please leave your object and your contact details at reception. You will receive a loan contract from ourselves as confirmation; you will also be included in the list of lenders and receive a voucher for free admission.
(Martina Oberprantacher)

TRANSLATE BEYOND CULTURE: THE POLITICS OF TRANSLATION

REPRINT:
HITO STEYERL, BEYOND CULTURE: THE POLITICS
OF TRANSLATION

HITO STEYERL

If there is any single buzz word of contemporary cultural discourse, it is the notion of translation. Hardly any other notion has made such a rapid career in the intellectual world. A concept of quite humble origins was suddenly elevated into the position of one of the key metaphors of modern political and cultural discourse. Like a magic spell in a fairy tale, translation is supposed to provide a key which opens every door and solves every problem of a globalising world. But how is it that a notion derived from concrete literary and linguistic practice has taken on such an important political, cultural and even emancipatory role?

Keeping pace with its new importance, the meanings of translation have multiplied. Translation is no longer exclusively used to describe the processes of communication between different languages, but also becomes a model of time-space, of geopolitical relations, of postnational identities, and ultimately even a metaphor of culture itself. According to Etienne Balibar, the language of Europe is not any of the existing national languages, but translation itself. Thus translation is being proposed as a base for a new European identity founded on cosmopolitan and migrant constituencies. But translation is not only deemed capable of replacing the old model of a community based on a common language, it is also used to explain the basic functions of consciousness, the creation of transnational subjectivities, the reconstruction of adamic language, the creation of the multitude, as well as the transfer from the political to the aesthetic sphere. We can describe the politics of display in a museum as a process of translation just as we can use translation to describe the so-called third space of postnational cosmopolitanism. It is supposed to form the base of the public sphere, just as it is used to suggest a new vision of emancipation. Ultimately, it even replaces the old notion of universality. In a postdialectical era, which is regarded as having overcome binary divisions and metaphysical thinking, translation provides a model for a process of unceasing mediation, which does not allow for fixed identities and stable border lines. Briefly speaking: there does not seem to be any problem in the world to which translation does not provide a solution.

But has the redemptive role that especially cultural translation was supposed to assume been realised? In an age, in which binary antagonisms are violently reestablished at all political, cultural and social levels all over the world, not least of all within the framework of the so-called war against terror, the model of translation seems to have had little effect. And its practical shortcomings cast doubt on many of the optimistic predictions about a new globalised cosmopolitism based on cultural translation. But we need not go so far to see that translation does not provide any solutions in situations, where the most energetic efforts are made to install new national languages or to conserve texts which are considered sacred. Let's remember the institutionalisation of various new national languages in the Europe of the nineties. In a classical example of a deeply politicised narcicissm of small differences, a huge bureaucracy of translation was installed, where actually no translation was needed at all. In many of these situations, translation actually created new divisions by installing artificial linguistic and cultural borders. Thus, translation not only

abolishes borders but also helps to create them. Has the notion of translation been overextended?

To understand the situation that the notion of translation has got itself into, let's remember the old joke of the command which was passed down a line of soldiers. An order which originally stated: "Turn left at the next corner" came out translated as: "Shoot yourself in the foot immediately". Has translation in this metaphorical sense shot itself in the foot? Or is translation still a valuable conceptual tool for understanding an impasse of social sciences and cultural studies, which was produced by obsessively translating political and social processes into cultural ones?

The project translate is intended to establish a platform to develop a thorough critique of the concept of cultural translation: by establishing its limitations, thus sharpening its profile and unfolding its concrete potential. Its inflationary use has concealed the radical consequences that a practical implementation of cultural translation would have for the realm of national culture, which is based on constructing exclusive national canons, national systems of education, and thus national cultural elites, which are firmly entrenched in the stable material conditions supporting them. Any real attempt to promote cultural translation would invariably change a system in which global culture is the result of the addition of national ones. But is there any concrete sphere of cultural or political articulation today for the constituencies of cultural translation identified by Balibar, namely cosmopolitans and migrants or other groups that are not supported by the traditional infrastructure of national culture and the political structure of the nation state? And where would that sphere be located? Is cultural translation a way of unfolding difference or managing it? What practical consequences does it have for working in a transnational framework? How is it actualised in artistic practice and within political and social movements? Translate will discuss those questions on a theoretical level and within the framework of ten artistic projects realised by our partner institutions.

QUI PEUT TRADUIRE? POLITIQUES DE LA TRADUCTION

RÉIMPRESSION:
PAUL B. PRECIADO,
QUI PEUT TRADUIRE? POLITIQUES DE LA TRADUCTION
"LIBÉRATION", 12.03.2021

PAUL B. PRECIADO

« [...] La traduction et la correction sont à l'industrie de l'édition ce que la gestation est à l'économie de la reproduction hétéro-patriarcale: l'auteur (et l'éditeur) est le père du texte ; le traducteur n'est qu'une mère porteuse, le transportant mot à mot d'une langue à l'autre. Comme les mères, les traducteurs et traductrices nettoient, soignent et rangent, mais celui qui donne le nom et touche la tune est l'éditeur, méta-père de livres et, seulement après, l'auteur. Rendre visible et reconnaître le travail des traducteurs et traductrices est une tâche urgente.

Deuxièmement, la traduction est toujours un processus politique. Rien ne permet de mieux comprendre la politique culturelle d'une nation que ses pratiques en matière de traduction. Il suffit de penser, par exemple, à la résistance en France entre 1980 et 2019 à la traduction des textes du féminisme noir, de la théorie queer ou de la théorie postcoloniale. Il a fallu attendre l'explosion numérique mondiale de Metoo et de Black Lives Matter pour que ces textes soient considérés comme du matériel d'édition potentiellement rentable. Maintenant, tout d'un coup, les maisons d'édition lancent des collections féministes et antiracistes et donc on se retrouve face à la question pertinente de savoir qui peut traduire ces textes. L'exigence posée par les traductions de bell hooks, Jack Halberstam ou Saidiya Hartman n'est pas celle de l'dentité, et certainement pas celle de l'ontologie - il ne s'agit pas de savoir si l'auteur et le traducteur partagent une "nature" commune, car le sexe, le genre et la race ne sont pas des natures, mais des constructions historiques et politiques. La race n'est pas un événement épidermique, une vérité naturelle, ni une ontologie de la pigmentation cellulaire, mais une technologie politique d'oppression. Néanmoins, la culture noire, comme la culture queer o trans, existent en tant que traditions culturelles et discursives, en tant qu'esthétiques de la résistance."

IL N'Y A PAS D'IDENTITÉ CULTURELLE

RÉIMPRESSION:
FRANÇOIS JULLIEN, IL N'Y A PAS D'IDENTITÉ CULTURELLE,
"L'HERNE," PARIS 2016
PP. 88-90

FRANÇOIS JULLIEN

"[...] Mais dans quelle langue, à l'échelle du monde, entre les cultures, se fera ce dialogue ? S'il ne peut se faire dans la langue de l'une ou de l'autre sans que soit déjà aliénée l'autre, la réponse pour une fois est simple : le dialogue ne peut se faire que dans la langue et de l'une et de l'autre, autrement dit entre ces langues : dans l'*entre* ouvert par la traduction. Puisqu'il n'est pas de langue tierce ou médiatrice (surtout pas l'anglais mondialisé ou le *globish*), la *traduction* est la langue *logique* de ce dialogue. Ou, pour reprendre une formule célèbre, mais en la transférant de l'Europe au monde, la traduction doit être la langue du monde. Le monde à venir doit être celui de l'entre-langues : non pas d'une langue dominante, quelle qu'elle soit, mais de la traduction activant les ressources des langues les unes en regard des autres. À la fois se découvrant les unes par les autres et se remettant au travail pour donner à passer de l'une à l'autre. Une seule langue serait tellement plus commode, il est vrai, mais elle impose d'emblée son uniformisation. L'échange en sera facilité, mais il n'y aura plus rien à échanger, plus rien en tout cas qui soit effectivement singulier. Tout se trouvant d'emblée rangé dans une langue et sans plus d'écarts la dérangeant, chaque langue-pensée – chaque culture – ne pourra plus alors, je l'ai dit, que revendiquer sur un mode identitaire et de façon têtue ses « différences ». La traduction, en revanche, est la mise en oeuvre élémentaire et probante du dia-logue. Elle en laisse paraître l'inconfort, le caractère non définitif, toujours en reprises et jamais achevé ; mais aussi ce qu'il a d'effectif : un commun de l'intelligence s'élabore dans son *entre* et vient à s'y déployer.

L'intelligence, en effet, telle que la développe la diversité des langues et des pensées, n'est pas un entendement fini, arrêté (tel que l'était l'entendement kantien des catégories). Mais plus elle est appelée à traverser d'intelligibilités diverses, comme dans le dia-logue des cultures, plus elle est appelée à se promouvoir : plus elle devient intelligente. C'est même là une chance de notre époque, à l'encontre de l'uniformisation mondiale, que de pouvoir, par la découverte d'autres langues et d'autres cultures, s'ouvrir à d'autres cohérences et, par suite, à d'autres modes d'intelligibilité. "

ÜBERSETZEN ALS GESPRÄCH

NACHDRUCK:
KAROLIN MEUNIER, ON VAI PURE,
READING SESSION 8, EDIT I, 2019

KAROLIN MEUNIER

Vai pure ist der Titel eines 1980 von Carla Lonzi bei Scritti di Rivolta Femminile in Mailand herausgegebenen Bandes.[1] Es ist auch dessen letzter Satz, mit dem Lonzi die Veröffentlichung eines Gesprächs mit ihrem Partner, dem Künstler Pietro Consagra abschließt. Die Übersetzung des Titels hängt also davon ab, wie man den Tonfall am Ende des Streitgesprächs interpretiert, das die Trennung ihrer Liebesbeziehung dokumentiert. Das Paar debattiert darin über Kunst, Produktivität, professionelle und persönliche Anerkennung und die feministische Bewegung in Italien, die Lonzi entscheidend mitgeprägt hat. Als Kunstkritikerin und Autorin hat sie immer wieder die Form des Gesprächs eingesetzt, um sich bestimmten sprachlichen Standards im öffentlichen ebenso wie im privaten Bereich zu verweigern.

Der Dialog von *Vai pure* ist bisher weder ins Deutsche noch ins Englische übersetzt worden; die hier abgebildete Annäherung an den Titel ist im Gespräch mit Paolo Caffoni entstanden.[2] Da ich kein Italienisch spreche, habe ich verschiedene Personen[3] gefragt, ob sie im Austausch mit mir sukzessive das gesamte Buch durchgehen, das heißt, es spontan, im Zuge des Vorlesens ins Englische übertragen. Diese Form der simultan übersetzenden, vorläufigen, sich selbst reflektierende Lektüre zersetzt den Text und erweitert ihn zugleich: Die Suche nach den richtigen Worten und die Reaktionen auf das Gelesene beginnen, den ursprünglichen Dialog zu überlagern. Wenn die transkribierten Gespräche von mir überarbeitet und veröffentlicht werden, wird eben dieser Prozess nachvollziehbar gemacht.[4] Auf diese Weise ist ein neues Textkonvolut entstanden, ein Kommentar, der die Aufmerksamkeit ebenso auf einzelne für Lonzi zentrale Begriffe lenkt, wie auf das spezifische Wissen der an diesem Experiment Beteiligten. Diese müssen sich nicht unbedingt in einer der beiden Sprachen zuhause fühlen, oder auch in keiner der beiden, und bringen stattdessen unterschiedliche Beziehungen zur Thematik ein, ob als Leserin Lonzis oder als Zeitzeugin der politischen Bewegungen im Italien der 1970er und 80er Jahre.

Teresa de Lauretis hat ihrer englischen Übersetzung der von der Mailänder Kooperative Libreria delle donne kollektiv verfassten und 1987 publizierten Textsammlung *Sexual Difference. A Theory of Social-Symbolic Practice*, eine Notiz vorangestellt: "Any act of translation is fraught with problems. The dense substratum of connotations, resonances, and implicit references that the history of a culture has sedimented into the words and phrases of its language is often simply untranslatable; thus the act of translation is often a rewriting of the original language (in this case, Italian) and a reconfiguration or interpretation of its plurivocal meaning by means of connotations and resonances built into the words and phrases of the second language (in this case, American English)."[5] Dass sich bestimmten Worten einer Sprache die lange Geschichte ihrer verschiedenen Anwendungen eingeprägt hat und das Übersetzen immer auch ein Neuschreiben ist, zeigt sich in den Schriften Lonzis am Beispiel des von ihr verwendeten Begriffs der *autenticità*, Authentizität. Was zunächst kein Übersetzungsproblem zwischen der italienischen, englischen und deutschen Sprache zu sein scheint, produziert dennoch einen Widerstand, den Ausdruck heute unkommentiert zu wiederholen. Auch in *Vai pure* kommt Lonzi mehrfach auf das Konzept der Authentizität zu sprechen. Giovanna

Zapperi übersetzt und kommentiert eine der betreffenden Stellen im Gespräch mit mir so: „Lonzi says: 'The woman is aware that she needs someone else – whereas the man is not – and brings into consciousness that he not only needs the woman, but also that his own humanity can only exist within this relationship to her. His humanity in the sense of authenticity.' So what does authenticity mean here? It means something that is opposed to culture or that is not a role, for example. Something that exists beyond all the places where society puts us. There is the idea of seeing authenticity as a process, as something that is not a state but a work in progress. Maybe another way to put it is to understand it in terms of what happens freely between human beings, something that is not instrumental. [...] Maybe that's the more productive way of understanding authenticity for us, in terms of the practice of liberation."[6]

Die sich ebenso ergänzenden wie widersprechenden Facetten eines Wortes oder Textes werden also nicht erst im Zuge der Übersetzung in eine andere Sprache offensichtlich, sondern ebenso in der Relektüre durch Menschen verschiedener Generationen und unterschiedlicher kultureller oder sozialer Zusammenhänge aufgerufen. Die mehrstimmigen Bedeutungen eines Wortes, von denen de Lauretis spricht, sind also nicht zwangsläufig unübersetzbar. Die bezugnehmende und aktualisierende Qualität von Übersetzung fordert vielmehr auf zum Gespräch, zum Neben- oder Nacheinander divergenter Definitionen.

1
Carla Lonzi, *Vai pure. Dialogo con Pietro Consagra*, Scritti di Rivolta Femminile, Mailand 1980
2
„Reading No. 08 with Paolo Caffoni". In: Karolin Meunier, *A Commentary on Carla Lonzi's* Vai pure, Archive Books/b_books, Berlin 2022
3
Die Gesprächspartner*innen sind Federica Bueti, Paolo Caffoni, Adriana Casalegno, Luisa Lorenza Corna, Raphael Cuomo, Chiara Figone, Allison Grimaldi Donahue, Maria Iorio, Ariane Müller, Alex Martinis Roe, Traudel Sattler, Stephanie Weber und Giovanna Zapperi.
4
Auszüge des Materials wurden als Performances aufgeführt. Eine vollständige Fassung der Übersetzungsgespräche erscheint 2022: Karolin Meunier, *A Commentary on Carla Lonzi's* Vai pure, Archive Books/b_books Berlin.
5
Teresa de Lauretis, „Note on Translation", in: Milan Women's Bookstore Collective. *Sexual Difference: A Theory of Social-Symbolic Practice*. Translated by Patricia Cigogna and Teresa de Lauretis. Bloomington/Indianapolis, 1990, S. 21 (Italienische Erstausgabe: *Non credere di avere die diritti*, Mailand 1987)
6
„Reading No. 13 with Giovanna Zapperi", In: Karolin Meunier, *A Commentary on Carla Lonzi's* Vai pure, Archive Books/b_books, Berlin 2022 .

DIRE QUASI LA STESSA COSA. ESPERIENZE DI TRADUZIONE

RISTAMPA:
UMBERTO ECO, DIRE QUASI LA STESSA COSA.
ESPERIENZE DI TRADUZIONE, BOMPIANI, MILANO 2013,
PP. 9-10.

UMBERTO ECO

"[...] Che cosa vuol dire tradurre? La prima e consolante risposta vorrebbe essere: dire la stessa cosa in un'altra lingua. Se non fosse che, in primo luogo, noi abbiamo molti problemi a stabilire che cosa significhi "dire la *stessa* cosa", e non lo sappiamo bene per tutte quelle operazioni che chiamiamo parafrasi, definizione, spiegazione, riformulazione, per non parlare delle pretese sostituzioni sinonimiche. In secondo luogo perché, davanti a un testo da tradurre, non sappiamo quale sia *la cosa*. Infine, in certi casi, è persino dubbio che cosa voglia dire *dire*.

[...]

Ecco il senso dei capitoli che seguono: cercare di capire come, pur sapendo che non si dice mai la stessa cosa, si possa dire *quasi* la stessa cosa. A questo punto ciò che fa problema non è più tanto l'idea della *stessa* cosa, né quella della stessa *cosa*, bensì l'idea di quel *quasi*. Quanto deve essere elastico quel *quasi*? Dipende dal punto di vista: la Terra è quasi come Marte, in quanto entrambi ruotano intorno al sole e hanno forma sferica, ma può essere quasi come un qualsiasi altro pianeta ruotante in un altro sistema solare, ed è quasi come il sole, poiché entrambi sono corpi celesti, è quasi come la sfera di cristallo di un indovino, o quasi come un pallone, o quasi come un'arancia. Stabilire la flessibilità, l'estensione del *quasi* dipende da alcuni criteri che vanno negoziati preliminarmente. Dire quasi la stessa cosa è un procedimento che si pone, come vedremo, all'insegna della *negoziazione*."

WAS SOLLEN, WAS KÖNNEN ÜBERSETZUNGEN VON LYRIK LEISTEN?

NACHDRUCK:
ÜBERARBEITETE FASSUNG EINES
ARTIKELS, DER ANFANG 2021 AUF "SALTO" ERSCHIENEN
IST, ANLÄSSLICH ZWEIER BESPRECHUNGEN
DER BUCHAUSGABE: ROBERTA DAPUNT, DIE KRANKHEIT
WUNDER/LE BEATITUDINI
DELLA MALATTIA, FOLIO VERLAG, WIEN, BOZEN 2020.

ALMA VALLAZZA

Roberta Dapunts Gedichte kennen (auch in Südtirol) viele. Sie werden auch von Leuten geschätzt, die sonst kaum Gedichte lesen. Wer die Autorin bei einem ihrer Auftritte erlebt hat, bleibt nachhaltig beeindruckt von ihrem Vortrag, von der auratischen Kraft ihrer Aussagen. Unter Südtirols Autor*innen ist sie die erste und bislang einzige, deren Gedichte in der renommierten *collana bianca* des Verlages Einaudi erscheinen. Hier hat sie bislang drei Bände vorgelegt, zuletzt, 2018, *Sincope*. Dieser wurde mit Italiens wichtigstem Preis für Lyrik, dem Repaci-Viareggio-Preis ausgezeichnet.

Anfang November 2020 ist im Folio Verlag der bei Einaudi bereits 2013 erschienene Band *Le beatitudini della malattia* in einer deutsch/italienischen Ausgabe, erweitert durch einige Übersetzungen ins Russische und Georgische erschienen. Hatte die italienische Ausgabe 2013 ein breites Presseecho erfahren und wird die Autorin mit diesem Zyklus, der um das Thema Demenz kreist, bis heute häufig zu Lesungen, auch im Rahmen von medizinischen Kongressen eingeladen, ist die Rezeption im deutschsprachigen Raum bislang verhalten ausgefallen. Angesichts von Corona-Zeiten möglicherweise nichts Verwunderliches, dennoch fällt auf, wie schwer sich die Kritik, die hiesige zumal, mit diesem Band in Übersetzung tut.

Doch ich möchte unterscheiden. Von den zwei bislang in Südtirol erschienenen Besprechungen ist eine die Lobes-, vielmehr die Liebeshymne des Schriftstellers Jörg Zemmler, der sich in seinem Radiobeitrag in der Sendung *Forum Literatur* vor einer großen Dichterin verbeugt und seine Begeisterung auf originelle und berührende Weise in Worte fasst. Ein wunderbar persönlicher Beitrag, allerdings: kein Wort zur Übersetzung. D.h., der Autor stellt sich zwar gleich eingangs eine entscheidende Frage, nämlich, ob es, bezugnehmend auf das Cover des Buches und den dort abgebildeten handschriftlichen Übersetzungsproben in diesem Buch um die Gedichte oder die Übersetzung gehe, entscheidet sich dann aber kurzerhand für erstere und liest sie im Original. Tja, schön für ihn, würde ich sagen, dass er als Südtiroler ausreichend Italienisch kann, um auf die Übersetzungen verzichten zu können. Schade aber für das Buch, dass sich gerade angeschickt hat, einem deutschsprachigen Publikum diesen Mehrwert anzubieten.

Explizit zur Übersetzung geäußert hat sich hingegen der Rezensent in der Weihnachtsausgabe des Südtiroler Wochenmagazin FF. Auffällig auch hier, dass aus der Perspektive des zweisprachigen Südtirolers geurteilt wird und man sich ob der eigenen Italienischkenntnisse berufen fühlt, die Entscheidungen der Übersetzer*innen zu korrigieren und die richtige Übersetzung einzelner Wörter statt der falschen oder wie der Rezensent sagt „ungenauen" Übersetzungen ohne den entsprechenden Kontext zu anzuführen.

Ist das genaue oder das am besten entsprechende Wort in jeder Übersetzung, insbesondere in jeder Gedichtübersetzung aber nicht gerade das zu Verhandelnde? Gilt es nicht, zusammen mit dem Analysieren syntaktischer und rhythmischer Strukturen gerade das Vokabular in all seiner oft vieldeutigen und ambivalenten Ausdrucksweise im Kontext des jeweiligen Gedichts zu prüfen? Und dafür in der anderen Sprache eine Entsprechung zu finden, die allerdings nie eine eindeutig richtige, in jedem Fall selten die nächstliegende des üblichen Sprachgebrauchs ist?

Schon lang hege ich den Verdacht und bin damit nicht allein, dass das Übersetzen in der dreisprachigen Provinz Südtirol paradoxerweise deshalb kaum Wertschätzung genießt und entsprechend auch keine Lobby und kaum Fürsprecher hat, um etwa den Translationswissenschaften an der Universität eine Fakultät einzurichten, weil es im Alltag von jedem praktiziert wird und das Übersetzen als bürokratische Notwendigkeit, nicht aber als intellektuell anspruchsvolle, kreative Tätigkeit angesehen wird. Von daher der Irrglaube, man könne auch in der Literatur zwischen einer richtigen und einer falschen Übersetzung unterscheiden, während es zwischen Original und Übersetzung in Wirklichkeit nie Deckungsgleichheit, sondern immer nur Annäherung gibt. Gewinnbringender wäre es allemal, sich damit zu beschäftigen, wie und mit welchen Mitteln eine Übersetzung diese Annäherung vollzieht und wie es ihr gelingt, zum einen das Original zur Geltung zu bringen, das heißt die Aufmerksamkeit auf dessen sprachliche Eigenheit, seine spezifische Färbung, Melodie und Tonlage zu lenken, zum anderen seine eigene Kondition, die der Übersetzung, zur Diskussion zu stellen.

Das Buch *die krankheit wunder / le beatitudini della malattia* handelt neben den Themen der Demenz und des Verlusts erworbener Erkenntnis- und Ausdrucksmöglichkeiten auch von Übersetzung. Es geht in diesem Band in vielfacher Hinsicht um die Möglichkeiten und Unmöglichkeiten menschlicher Kommunikation – der Übersetzung von Wahrnehmungen und Gefühlen mithilfe der Sprache. Es geht um schmerzliche Momente des Verstummens und des Verlusts von Ausdrucksmöglichkeiten, aber auch um die beglückenden Momente der Benennung und Verständigung. Titelgebend und zentral ist der Begriff der *beatitudine*, des Wunders/des Geheimnisses/der Glückseligkeit der Krankheit, dem „vollkommenen zustand/der erinnerungen die keine augen mehr haben und nicht zurückschauen". So wie die Gedichte das Zwiegespräch mit Uma, der an Alzheimer erkrankten Mutter dokumentieren und dabei den Zustand der Krankheit sowohl als Schreckens- wie auch als Sehnsuchtsort umkreisen, umkreist die Inszenierung dieses mehrsprachigen Bandes das Thema der Übersetzung.

Für die Übersetzungen und für die Gestaltung des Buches zeichnet eine neunköpfige Gruppe des Übersetzerkollektivs Versatorium aus Wien. Das Übersetzen im Kollektiv ist nur eine Besonderheit des exzentrischen Übersetzungsvorhabens, dem sich diese Gruppe verschrieben hat. Es zeigt sich formal und gestalterisch unter anderem in der rigorosen Kleinschreibung, der unerwarteten Abfolge von Original und Übersetzung, die im Buch immer wieder abgeändert wird, im Verzicht der Paginierung der Seiten und an der Fülle weißer Seiten, die hier zwischen die Gedichte eingezogen wurden. Sprachlich sorgen vor allem die oft abwegig anmutende Wortwahl und der streng am Original ausgerichtete Satzduktus für Irritation. Beinahe stammelnd, nachsprechend folgen diese Übersetzungen dem Original, als wollten sie bewusst ihre eigene Souveränität untergraben oder jede falsche Virtuosität vermeiden, um zuallererst den Wörtern des Originals in ihrer exakten Setzung oder auch Schieflage gerecht zu werden.

Für mich, die ich selbst Übersetzerin bin und selbst Gedichte von Roberta Dapunt übersetzt habe und um die „verzagtheit des sagens"

auch in dieser Lyrik weiß, ist dieses Buch ein sehr gelungenes, mutiges Experiment, gerade auch wegen der Art und Weise, wie es den Vorgang des Übersetzens vorführt und inszeniert, wofür sowohl dem Übersetzerkollektiv als auch dem Folio Verlag Respekt gebührt. Ich anerkenne es als das Angebot an die Leserin, den Leser, die Gedichte im Original und in der Übersetzung in einem Zwiegespräch zu erleben, in dem das Verhältnis der Sprachen zueinander thematisiert und Einblick gewährt wird in den unabschließbaren Leseprozess, der das Übersetzen letztendlich ist.

INTRODUCTION À UNE POÉTIQUE DU DIVERS

RÉIMPRESSION:
EDOUARD GLISSANT: LANGUES ET LANGAGES
PP. 45-46,
INTRODUCTION À UNE POÉTIQUE DU DIVERS,
EDITIONS GALLIMARD, PARIS, 1996

EDOUARD GLISSANT

"[...] Je voudrais pour finir faire quelques brèves considérations sur ce que je considère comme un des arts futurs les plus importants l'art de la traduction. Ce que toute traduction suggère désormais en son principe, par le passage même qu'elle ferait d'une langue à l'autre, c'est la souveraineté de toutes les langues du monde. Et la traduction pour cette même raison est le signe et l'évidence que nous avons à concevoir dans notre imaginaire cette totalité des langues. De même que l'écrivain réalise cette totalité désormais par la pratique de sa langue d'expression, de même le traducteur la manifeste mais par le passage d'une langue à une autre, confronté à l'unicité de chacune de ces langues. Mais, tout comme dans notre chaos-monde on ne sauvera aucune langue du monde en laissant périr les autres, de même le traducteur ne saurait-il établir relation entre deux systèmes d'unicité, entre deux langues sinon en présence de toutes les autres, puissantes dans son imaginaire, quand bien même il n'en connaîtrait aucune. Qu'est-ce à dire, sinon que le traducteur invente un langage nécessaire d'une langue à l'autre, comme le poète invente un langage dans sa propre langue. Une langue nécessaire d'une langue à l'autre, un langage commun aux deux, mais en quelque sorte imprévisible par rapport à chacune d'ettes. Le langage du traducteur opère comme la créolisation et comme la Relation dans le monde, c'està- dire que ce langage produit de l'imprévisible. Art de l'imaginaire, dans ce sens la traduction est une véritable opération de créolisation, désormais une pratique nouvelle et imparable du précieux métissage culturel. Art du croisement des métissages aspirant à la totalité-monde, art du vertige et de la salutaire errance, la traduction s'inscrit ainsi et de plus en plus dans la multiplicité de notre monde. La traduction est par conséquent une des espèces parmi les plus importantes de cette nouvelle pensée archipélique. Introduction à une Poétique du Divers Art de la fugue d'une langue à l'autre, sans que la première s'efface et sans que la seconde renonce à se présenter. Mais aussi art de la fugue parce que chaque traduction aujourd'hui accompagne le réseau de toutes les traductions possibles de toute langue en toute langue. S'il est vrai qu'avec toute langue qui disparaît, disparaît une part de l'imaginaire humain, avec toute langue qui est traduite s'enrichit cet imaginaire de manière errante et fixe à la fois. La traduction est fugue, c'est-à-dire si bellement renoncement. Ce qu'il faut peut-être le plus deviner dans l'acte de traduire, c'est la beauté de ce renoncement. Il est vrai que le poème, traduit dans une autre langue, laisse échapper de son rythme, de ses assonances, du hasard qui est à la fois l'accident et la permanence de l'écriture. Mais il faut peut-être y consentir, consentir à ce renoncement. Carje dirai que ce renoncement est, dans la totalité-monde, la part de soi qu'on abandonne, en toute poétique, à l'autre. Je dirai que ce renoncement, quand il est étayé de raisons et d'inventions suffisantes, quand il débouche sur ce langage de partage dont j'ai parlé, est la pensée même de l'effleurement, la pensée archipélique par quoi nous recomposons les paysages du monde, pensée qui, contre toutes les pensées de système, nous enseigne l'incertain, le menacé mais aussi l'intuition poétique où nous avançons désormais. La traduction, art de l'effleurement et de l'approche, est une pratique de la trace. Contre l'absolue limitation de l'être, l'art de la traduction concourt à amasser l'étendue de tous les étants et de tous les existants du monde. Tracer dans les langues, c'est tracer dans l'imprévisible de notre désormais commune condition."

CULTURAL TRANSLATION: WHY IT IS IMPORTANT AND WHERE TO START WITH IT

REPRINT:
BORIS BUDEN, CULTURAL TRANSLATION:
WHY IT IS IMPORTANT AND WHERE TO START WITH IT,
HTTPS://TRANSVERSAL.AT

BORIS BUDEN

Let me introduce the problem by quoting one question: "Every five years one of the most important exhibitions of modern and contemporary art takes place in Kassel. What is it called?"

People interested in culture and arts, mostly members of the well-educated middle class, also known in Germany as Bildungsbürgertum, can, for sure, easily answer this question. But the question is not addressed to them. In fact this is the 85th question of a test, which one has to pass (in the federal state of Hessen) in order to achieve German citizenship. There are actually many more other questions (100 altogether) in the test, mostly dealing with German history, German Constitution, civil rights, the German juridical and political system, German culture, sport, national symbols, etc. Some of the questions are quite peculiar. For instance: "A woman shouldn't be allowed to go out in public or to travel alone without a company of male relatives. What is your opinion on this?"; "Please explain the right of Israel to exist", or "If someone says the Holocaust is a myth or a fairy tale, what would you answer?", etc.

Let us put aside the content of these questions and ask rather what their purpose actually is, or more precisely, what the purpose of these hundred correct answers is. They are all together supposed to be an answer to one particular question: "What is German". In other words, they are supposed to describe the content of the notion of "German identity". They are, if you like, some sort of a small and quick – an instant – canon of features supposed to definitely separate German from non-German, that is to draw a boundary line between them and so to exclude the Other from the German.

In fact, all hundred questions are constructed as a sort of a canon of canons. There is a canon of German literature: notorious Goethe, Schiller, the winners of the Nobel-prize such as Heinrich Boell, Thomas Mann, etc; there is furthermore a canon of the biggest German rivers, of the highest mountains; a canon of the most important historical events as well as a canon of the most famous German scientists; of course there is also a canon of the most important cultural features or values, which define German cultural identity in terms of a German "way of life" (the way "a real German", allegedly, treats women, children, different religions, different opinions, etc).

In its content as well as in its practical application the test is a perfect example of the fundamental contradiction of an identitarian discourse: the contradiction between its essentialist claims and its self-constructed character.

It is not difficult to see how arbitrary this self-construction has been made. Even its actual political motivation (the exclusion of one particular identity, the so-called Islamist one) is completely disclosed. On the other hand this bunch of features is openly attached (one could also say: essentialized) to the allegedly unique, original character of being German. Does really knowing what happens with contemporary art every five years in Kassel really make you German? It sounds stupid, but in the context of the test for German citizenship the answer is – yes! How then to deal with this nonsense, which has to be taken quite seriously, for its effects – being granted or not granted citizenship of one democratic, relatively rich and stable society – can decide not only one's quality of life, but also one's own fate?

Moreover, this nonsense – more precisely the above mentioned contradiction behind it – informs in a fundamental way what we perceive as our political reality today, for it creates its very basement, the human substratum of the society: it decides directly who belongs and who doesn't to the society we live in and so shapes the forces our political reality is made of. The example of German the citizenship-test is therefore only one, more visible, manifestation of a common principle: our societies and consequently our perception of the political reality are culturally framed. This throws light on one of the most striking phenomena of the "postmodern condition", the so-called cultural turn. Culture has not, as it is often believed, simply pushed away the notion of society from the political stage and taken its leading role in theoretical debates and practical concerns of political subjects. The change is more radical. Culture has become this very stage, the very condition of the possibility of society and of our perception of what political reality is today. This is the reason why democracy, that is the quest for freedom and equality, as well as the pursuit of social justice, welfare etc. appear today as being culturally determined.

It is in this context that the notion of translation, or more precisely, of cultural translation has got an immense importance. For it can be applied on both sides of the contradiction between essentialist and constructivist understanding of culture, that is either in order to arrange relations between different cultures or in order to subvert – as a sort of a reconstructed universalism – the very idea of an original cultural identity. In other words, the concept of cultural translation can be generally understood and applied in service of both contradictory paradigms of postmodern theory and postmodern political visions: multiculturalism and deconstruction.

As it is well known, multiculturalism is based on the concept of the uniqueness and originality of cultural formations. It assumes that there is an essential connection between culture and racial, sexual or ethnic origin. From this perspective multiculturalism challenges the very idea of universality, for it sees every universal concept as culturally relative. There is no universal culture, but a plurality of different cultures either tolerantly recognizing or violently excluding each other. For multiculturalists our world is nothing but a sort of cluster of different identities that we will never be able to sublate. To give an example: in the field of literature, multiculturalism would challenge the notion of world literature, that is the idea of a canon of masterpieces, which, as Goethe once stated, articulate in the best way what is universal in human nature. From the multicultural point of view there is only a plurality of specific canons instead, each of them originating in some sort of essential identity. Therefore we cannot talk about world literature, but only about "German", "French", or "white, "black", or "male", "female", "gay" literature including also a combination of these identitarian features like "white male", "black female", or "Latin-American-black-female", etc. literature or culture.

Multiculturalism is the very base of what we call identitarian politics – a political practice, which still decisively shapes our world today. Although it emphasizes the rights of minorities and marginal communities within a homogenized space of nation state, it legitimates at the same time the right of a specific national or ethnic community

to protect – as a majority within the political frame of the nation state – its allegedly unique and original cultural identity. Even our major political visions concerning further development of democracy and prosperity – like the project of European integration – basically follow the same multicultural pattern.

Deconstruction challenges the concept of multiculturalism in its very kernel, in its essentialism, that is, in the idea that every identity has an origin in some sort of a pregiven essence. A culture is for deconstructivists a system of signs, a narrative without any historical or physical origin. Signs are in relation only with one another. This applies even to the difference between signs and non-signs, which constitutes still another level of the sign system. According to this approach, there are no origins at all, but only their traces, only their copies instead and there is no end to the progression or regression of signs in space and time.

This actually means that cultures, too, are never reflections of some natural state of things, but rather constitute or construct their own origin, beyond any racial, sexual, ethnic or genetic essence. Therefore, being "German" or being "black", "female", "gay" etc. is simply a product of a specific cultural activity, a sort of cultural construction. For deconstruction every identity is from its very beginning culturally constructed.

In the case of nations, to repeat it, there is a belief that nations are given, that they persist over time as sort of timeless and eternal essences, that they can be clearly distinguished from other nations, have stable boundaries etc.

This means that they are, to use the well-known phrase coined by Benedict Anderson, imagined communities, which implies that the so-called unity of nation has been constructed through certain discursive and literary strategies. Nation is narration, writes Homi Bhabha. It emerges in human history at certain points in time and as a consequence of certain economic and socio-cultural development. For Gellner these are the conditions for the production of standardized, homogenous, centrally sustained high culture: a free market in commodities as well as labor for instance, or the emergence of a civil society, which can be sufficiently differentiated from the state, so that a sphere of autonomous culture could develop, etc. The so-called national cultures, which nationalists claim to defend and revive, are for Gellner their own inventions.

This is extremely important for our understanding of the phenomenon of translation. Its social and political role becomes clear only on the ground of the historical process of nation building. Only in this context translation acquires meaning, which transcends a purely linguistic horizon and becomes a cultural and political phenomenon, something we call today "cultural translation".

But what actually is translation ?

A traditional theory of translation understands it as a binary phenomenon: there are always two elements of a translating process, an original text in one language and its secondary production in some other language. It is therefore its relation to the original, which decisively determines every translation. This relation can be of a different nature. For Schleiermacher for instance, a translation has two

major possibilities: it could either move the reader towards the author, that is, strictly follow the original, or rather move the author towards the reader, that is, make the original text in the translation as understandable as possible. Schleiermacher preferred the first option, which implicates that translation provokes on the reader's side a certain feeling of strangeness (das Gefuehl des Fremden) or, as Schleiermacher says, "the impression that they are confronted with something foreign" (dass sie Auslaendisches vor sich haben).

This is typical of the early romantic theory of translation. Actually it does not have, as so many people believe, a fear of alienation (Verfremdung). On the contrary, it welcomes what is strange, different and foreign. Humboldt even urges translators to be faithful to the strangeness of a foreign language and foreign culture and to articulate this strangeness in their translations. Otherwise they would betray – not an original, as one could believe – but their own language, their own nation. Why?

Because for Humboldt the faithfulness of translation is a patriotic virtue. The purpose of translation is not to facilitate the communication between two different languages and cultures, but to build one's own language and, since Humboldt equates language and nation, the actual purpose of translation is to build the nation.

However, the concept of cultural translation, as we understand it today, hasn't arisen out of the traditional translation theory but rather out of its radical criticism articulated for the first time at the beginning of the twenties in Walter Benjamin's seminal essay "The task of the translator".

In his text – and this is essentially new – Benjamin actually got rid of the idea of the original and therefore of the whole binarism of traditional translation theory. A translation for Benjamin does not refer to an original text, it has nothing to do with communication, its purpose is not to carry meaning, etc. He illustrates the relation between the so-called original and translation by using the metaphor of a tangent: translation is like a tangent, which touches the circle (i.e. the original) in one single point only to follow thereafter its own way.

Neither the original nor the translation, neither the language of the original nor the language of the translation are fixed and persisting categories. They don't have essential quality and are constantly transformed in space and time.

This is the reason why Benjamin's essay became so important for the deconstructionist theory for it so vehemently questions the very idea of an essential origin.

Out of the same deconstructivist tradition emerges also the concept of cultural translation. It has been coined by one of the most prominent theoreticians of the so-called postcolonial condition, Homi Bhabha. His motivation was originally the criticism of multiculturalist ideology, the need to think about culture and about relations between different cultures beyond the idea of unique, essential cultural identities and communities originating in these identities. Nota bene: There is also a multiculturalist concept of cultural translation. Its political purpose is the stability of the liberal order, which can be achieved only on the grounds of non-conflictual, interactive relations between different cultures in terms of the so-called multicultural cohabitation.

This is the reason why liberal multiculturalists understand cultural translation always as an "inter-cultural translation".

For Homi Bhabha this would only bring us to the deadlock of identitarian politics, helplessly obsessed with cultural diversity. Therefore, he suggests instead the concept of the so-called third space. The third space is the space for hybridity, the space for– as he writes in The Location of Culture – subversion, transgression, blasphemy, heresy etc. He believes that hybridity – and cultural translation, which he regards as a synonym for hybridity – is in itself politically subversive. Hybridity is also the space where all binary divisions and antagonisms, typical for modernist political concepts, including the old opposition between theory and politics, do not work any more.

Instead of the old dialectical concept of negation, Bhabha talks about negotiation or translation as the only possible way to transform the world and bring about something politically new. So in his view, an emancipatory extension of politics is possible only in the field of cultural production following the logic of cultural translation.

American feminist philosopher Judith Butler uses Bhabha's concept of cultural translation to solve one of the most traumatic problems of postmodern political thought – the above mentioned problem of universality. For Butler the fact that no culture can claim universal validity does not mean that there is nothing universal in the way we experience our world today. The universality she means has also become the problem of cross-cultural translation. It is an effect of exclusion/inclusion processes.

Butler's formula is: Universality can be articulated only in response to its own excluded outside. What has been excluded from the existing concept of universality puts this concept – from its own outside – under pressure, for it wants to be accepted and included into the concept. However, this couldn't happen unless the concept itself has changed as far as necessary to include the excluded. This pressure finally leads to a rearticulation of the existing concept of universality. The process by which the excluded within the universality is readmitted into the term is what Butler calls translation. Cultural translation – as a "return of the excluded" – is the only promoter of today's democracy. It pushes its limits, brings about social change and opens new spaces of emancipation. It does so through the subversive practices, which change everyday social relations.

Let's emphasize again: the way social change is brought about here is not dialectical. It is transgressive instead. It doesn't happen as a result of clashes between social antagonisms respectively through the process of negation, but through a never-ending transgression of the existing social and cultural limits, through non-violent, democratic, translational negotiations.

Butler's concept of political change through the process of cultural translation still doesn't transcend a generally liberal framework. Gayatri Spivak has gone a step beyond it - which is articulated under similar premises of the postmodern and/or postcolonial reflection and also operates with the notion of translation - with her concept of "strategic essentialism".

Spivak knows very well that by means of today's theoretical reflection we can radically deconstruct almost every possible identity

and easily disclose its essentialism as being simply imagined, constructed, etc. However, the politics proper still works with these essential identities – such as nation for instance – as if it wouldn't know that they are only our illusions. Therefore, if we want to bring about some real political change, she suggests "a strategic use of positivist essentialism in a scrupulously visible political interest"[1].

This is the reason why the concept of "strategic essentialism" should be understood as a kind of translation, too. For the historical situation we live in articulates itself in two different languages: that of postmodern anti-essentialist theory and that of a parallel, old essentialist political practice. Spivak's concept of "strategic essentialism" simply admits that there is no direct correspondence between these two languages – they cannot be sublated in an old dialectical way by a third universal term which could operate as a dialectical unity of both. Therefore, the only possible way of a communication between them is a kind of translation.

But how does this translation actually work? As it seems, the right answer has been given already in 1943. By Bertolt Brecht:

"In Los Angeles, before the judge who examines people trying to become citizens of the United States, came an Italian restaurant keeper. After grave preparations, hindered, though, by his ignorance of the new language, in the test he replied to the question:

What is the 8th Amendment? falteringly: 1492. Since the law demands that applicants know the language, he was refused. Returning after three months spent on further studies, yet hindered still by ignorance of the new language, he was confronted this time with the question:

Who was the victorious general in the Civil War? His answer was:1492. (Given amiably, in a loud voice). Sent away again. And returning a third time, he answered a third question:

For how long a term are our Presidents elected? Once more with: 1492. Now the judge, who liked the man, realized that he could not learn the language.

He wanted to know how he earned his living and was told: by hard work. And so, at his fourth appearance, the judge gave him the question: When was America discovered?

And on the strength of his correctly answering 1492, he was granted his citizenship."

<div align="center">1</div>

Gayatri Spivak, *In Other Worlds: Essays in Cultural Politics*, New York : Methuen, 1987, p. 205.

PUBLIKATION / PUBBLICAZIONE / PUBLICATION

Dieses Buch erscheint anlässlich der Ausstellung / Questo volume è pubblicato in occasione della mostra / This book is published on the occasion of exhibition

THE POETRY OF TRANSLATION

Künstler*innen / Artisti e Artiste / Artists
Carla Accardi, Kader Attia, Katja Aufleger, Babi Badalov, Marilla Battilana, Mirella Bentivoglio, Tomaso Binga, Irma Blank, Lenora De Barros, Augusto De Campos, Anna Esposito, Amalia Etlinger, Ettore Favini, Freundeskreis, Michele Galluzzo & Franziska Weitgruber, Heinz Gappmayr, Elisabetta Gut, Jorel Heid & Alexandra Griess, Johann Georg Hettinger, Siggi Hofer, Annika Kahrs, Kinkaleri, Lena Iglisonis, Ketty La Rocca, Lucia Marcucci, Franco Marini, Otto Neurath, Franz Pichler, Anri Sala, Slavs and Tatars, Maria Stockner, Christine Sun Kim & Thomas Mader, Ben Vautier, Jorinde Voigt, Lawrence Weiner, Leander Schwazer, Cerith Wyn Evans

13.11.2021 - 13.02.2022
Kunst Meran Merano Arte

Kuratiert von / A cura di / Curated by
Judith Waldmann

Kuratorische Assistentin / Assistente alla curatela / Curatorial assistance
Anna Zinelli

Herausgeber / A cura di / Edited by
Kunst Meran Merano Arte, Judith Waldmann

Redaktionelle Koordination / Coordinamento editoriale / Editorial coordination
Federica Bertagnolli

Texte von / Testi di / Texts by
Boris Buden, Umberto Eco, Edouard Glissant, François Jullien, Karolin Meunier, Martina Oberprantacher, Paul B. Preciado, Hito Steyerl, Alma Vallazza, Judith Waldmann

Werktexte / Schede delle opere / Description of the works
Galerie mor charpentier, Paris; Laura Amann, Grazia Barbiero, Franco Bernard, Federica Bertagnolli, Carla Brunke, Freundeskreis feat. Déborah, Sabine Gamper, Andreas Hapkemeyer, Jenni Henke, KW Institute for Contemporary Art, Berlin; Langen Foundation, Neuss, Martina Oberprantacher, Kristina Scepanski, Felicitas Schwanemann, Mitch Speed, Bernhard Tuider, Judith Waldmann, Anna Zinelli

Übersetzungen / Traduzioni / Translations
Gareth Norbury, Anna Zinelli

Lektorat / Correzione bozze / Proofreading
Asia Maria Andreolli, Gianfranco Antonello, Federica Bertagnolli, Martina Oberprantacher, Shpresa Perlaska, Helmut Waldmann, Judith Waldmann, Rosemarie Waldmann, Anna Zinelli

Partner*innen / Partner / Partners
Ensemble Conductus, Art Verona Level 0 (The Gallery Apart), ÓPLA – Archiv für Künstler*innen Kinderbücher/ Archivio del libro d'artista per bambini

Außenstelle der Ausstellung / Sede aggiuntiva / External exhibition side
Krankenhaus Meran / Ospedale di Merano (Lawrence Weiner, Heinz Gappmayr)

Pressebüro / Ufficio stampa / Press office
Irene Guzman

Berater / Consulente / Consultant
Antonio Scoccimarro (Mousse Publishing)

Gestaltung / Grafica / Design
Gloria Favaro (Mousse Publishing)

Fotonachweis / Credits fotografici / Photocredits
Thorsten Arendt: S. / p. 21 (detail); S. / p. 49 (up)
Archiv Bildraum: S. / pp. 28-29 (details); S. / pp. 70-71
Federica Bertagnolli: S. / pp. 51-52; S. / p. 85
Ivo Corrà: S. / pp. 36-37 (details), S. / p. 41 (se non cambia); S. / pp. 43-44; S. / p. 63; S. / p. 75; S. / pp. 77-79
Franco Marini: S. / p. 53
Karlheinz Sollbauer: S. / p. 76

Druck / Stampato da / Printed by
Athesia Druck

Herausgegeben und vertrieben von /
Pubblicato e distribuito da / Published
and distributed by
Mousse Publishing
Contrappunto s.r.l.
Via Decembrio 28
20137, Milano

Verfügbar durch / Disponibile attraverso /
Available through
Mousse Publishing, Milan
moussemagazine.it

DAP | Distributed Art Publishers, New York
artbook.com

Les presses du réel, Dijon
lespressesdureel.com

Antenne Books, London
antennebooks.com

Erste Ausgabe / Prima edizione / First edition
2022

Gedruckt in Italien / Stampato in Italia /
Printed in Italy

ISBN 9788867495122

€ 18 / $ 20

Ein besonderer Dank geht an /
Un ringraziamento particolare a /
Special thanks to
allen Steuerzahler*innen /
tutti i e le contribuenti /
all the taxpayers
allen Künstler*innen /
tutte le artiste e gli artisti /
all the artists
allen Autor*innen /
tutte le autrici e gli autori /
all the authors
allen Leihgeber*innen /
tutte le prestatrici e i prestatori /
all the lenders
Elena Bini (Museion Bozen / Bolzano)
Paolo Cortese (Gramma_Epsilon Gallery,
Roma / Athens)
Bart van der Heide (Museion Bozen / Bolzano)
Rodolfo Garau
Andreas Hapkemeyer (Museion Bozen / Bolzano)
Ifa – Institut für Auslandsbeziehungen
Paola Mattedi
GALERIE POGGI, Paris
Bernhard Tuider, Sammlung für Plansprachen und
Esperantomuseum, Österreichische
Nationalbibliothek, Wien
Universal Music Publishing, Berlin

Allen Autor*innen wurde die Verwendung einer
geschlechtsspezifischen Formulierung freigestellt.
Soweit personenbezogene Bezeichnungen nur
in männlicher Form angeführt sind, beziehen sie
sich auf alle Geschlechter in gleicher Weise.

L'utilizzo di formule di linguaggio inclusivo
di genere (come ad esempio l'asterisco) è stato
lasciato a discrezione di ogni autore o autrice.
Nei casi in cui le indicazioni personali siano
espresse solamente in forma maschile, esse si rife-
riscono allo stesso modo a qualunque genere.

The use of gender-inclusive formulas (e.g. aste-
risks) has been left to the discretion of each
author. Where only the masculine form is given
this will refer equally to persons of all genders.

Mit der Schirmherrschaft der Gemeinde Meran /
Con il patrocinio del Comune di Merano /
With the patronage of the municipality of Merano